MAXFIELD PARRISH

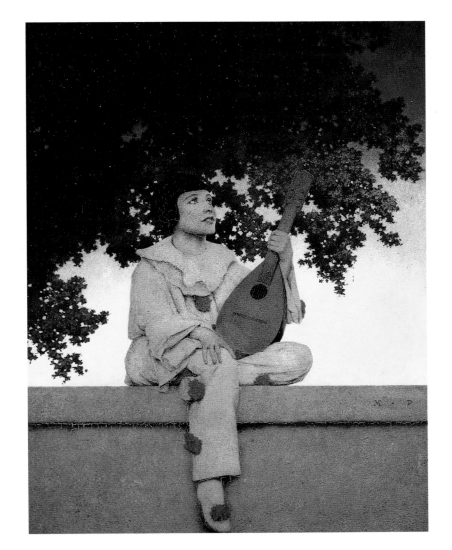

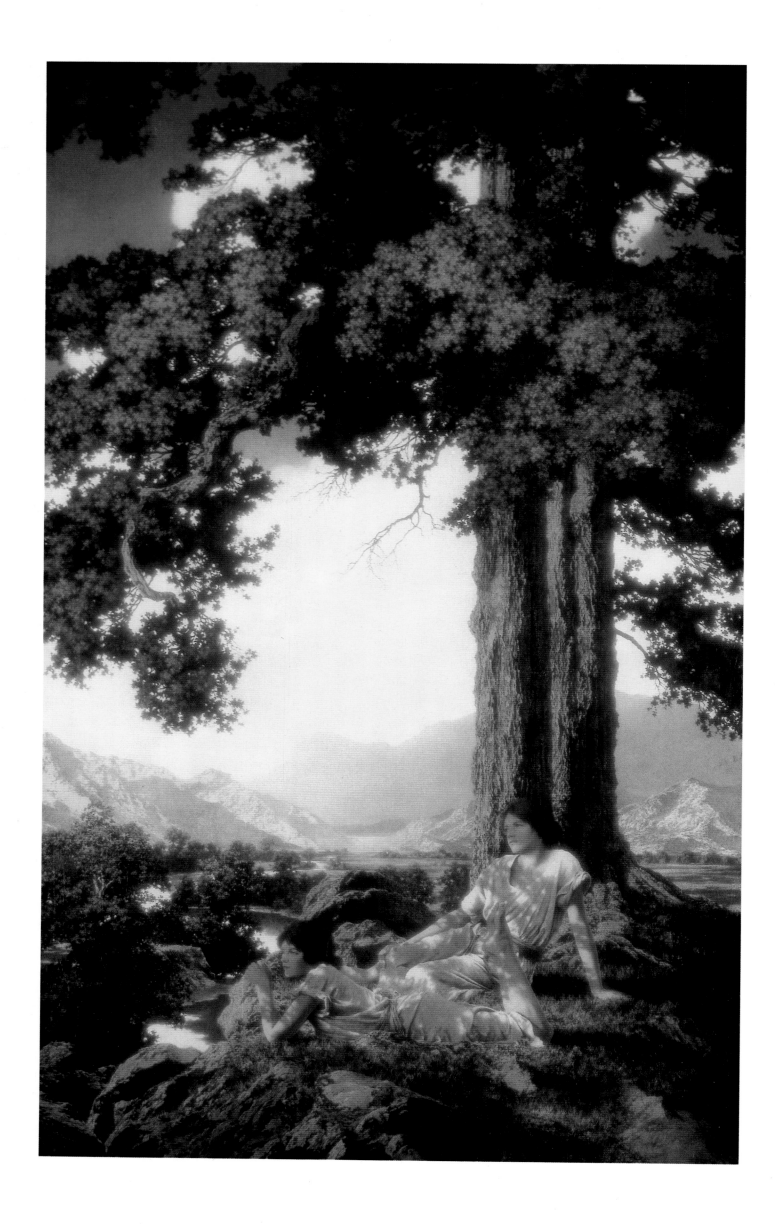

MAXFIELD PARRISH

Laurence S. Cutler, Judy Goffman and
the American Illustrators Gallery

Crescent Books
New York/Avenel, New Jersey

Acknowledgments

The authors would like to graciously thank the following persons and institutions who assisted us in the task of assembling, assimilating, and synthesizing this book: Betty Skillen, the niece of Susan Lewin and executrix of her estate, was kind enough to share her personal recollections, Susan Lewin's collection of photographic glass plates (taken by Parrish himself), and other memorabilia with us. Virginia Reed Colby, step-daughter-in-law of Susan Lewin, was most kind and helpful in answering our many questions; Joanna Parrish Gordon, granddaughter of Maxfield Parrish, daughter of Maxfield Parrish, Jr., went through her collection of family heirlooms and shared everything with us. Among the items Joanna found was her grandfather's personal copy of Jay Hambidge's book, *The Dynamic Symmetry of the Greek Vase*. John Goodspeed Stuart of The Parrish House was forthcoming with sources and suggestions and for this we thank him. The venerable Vose Gallery of Boston could not have been more accommodating. Both Terry and Bill (Abbot Williams) Vose opened their historic family/business archives to us. Anne Schmoll of the Vose staff was also very helpful. Vose is to be commended for their continued interest in the academic pursuits which conjoin the business aspects of the gallery world with scholarly pursuits. We would also like to thank Chris Erbe of Julius Lowy for his help with the photography; Betsy Brown and Diana Peterson of The Quaker Collection, Haverford College Library, Haverford, Pennsylvania; Philip N. Cronenwett, Chief of Special Collections, Baker Library, Dartmouth College, Hanover, New Hampshire; Elyssa B. Kane of the Pennsylvania Academy of Fine Arts; The Delaware Art Museum Library, Wilmington, Delaware; The Brandywine River Museum, Chadds Ford, Pennsylvania; The Society of Illustrators in New York for opening their library to us on a hot August day, when it was actually closed for the summer; The Thomas J. Watson Library of The Metropolitan Museum of Art, of New York; The Mask and Wig Club of the University of Pennsylvania, of Philadelphia; the staff of the American Illustrators Gallery, New York, and most especially Jennifer Paige Goffman and Kristen Thomas for their invaluable assistance; and the late Maxfield Parrish, Jr. for the warm and humorous letters he sent us, with their enlightening drawings and cartoons, explaining, augmenting, and verifying his father's works.

This 1993 edition published by Crescent Books, distributed by Outlet Book Company, Inc., a Random House Company, 40 Engelhard Avenue Avenel, New Jersey 07001

Produced by Brompton Books Corporation 15 Sherwood Place Greenwich, CT 06830

ISBN 0-517-06714-5

8 7 6 5 4 3 2 1

Printed and bound in Italy

Page 1:
Her Window, 1922
Cover, *Life*, August 24, 1922
Oil on panel, 14¾ × 11½ in.
Private Collection
Courtesy: The American Illustrators Gallery (LUD 676)

Page 2:
Hilltop, 1926
Oil on panel, 35⅛ × 21¾ in.
Issued Dec. 1926 or early 1927, The House of Art
Print sizes: 16 × 10 in., 20 × 12 in., 30 × 18 in.
Courtesy: The American Illustrators Gallery (LUD 722)

Pages 4-5:
Study for Old King Cole, 1895
Oil on canvas, ca. 5 × 12 ft.
Mural painted for the Mask and Wig Club,
The University of Pennsylvania, Philadelphia, PA
Courtesy: The American Illustrators Gallery and the Pennsylvania Academy of Fine Arts (LUD 722)

Note: Coy Ludwig, author of *Maxfield Parrish*, (Watson-Guptill Publications: New York, 1973) extended the numbering system Parrish himself created for identifying his illustrations. The LUD numbers listed in this book refer to Mr. Ludwig's system, which is the only one in existence for Maxfield Parrish.

Dedication
This book is dedicated to our loving children, Zachary and Max Cutler, and Andrew and Jennifer Goffman and to their respective grandparents: Hermann and Doris; and Abe and Bea, who really made it possible.

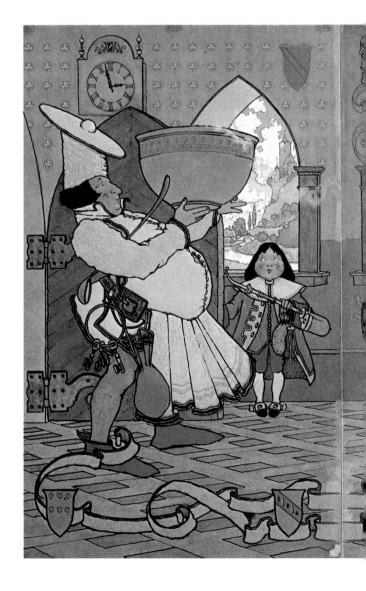

Contents

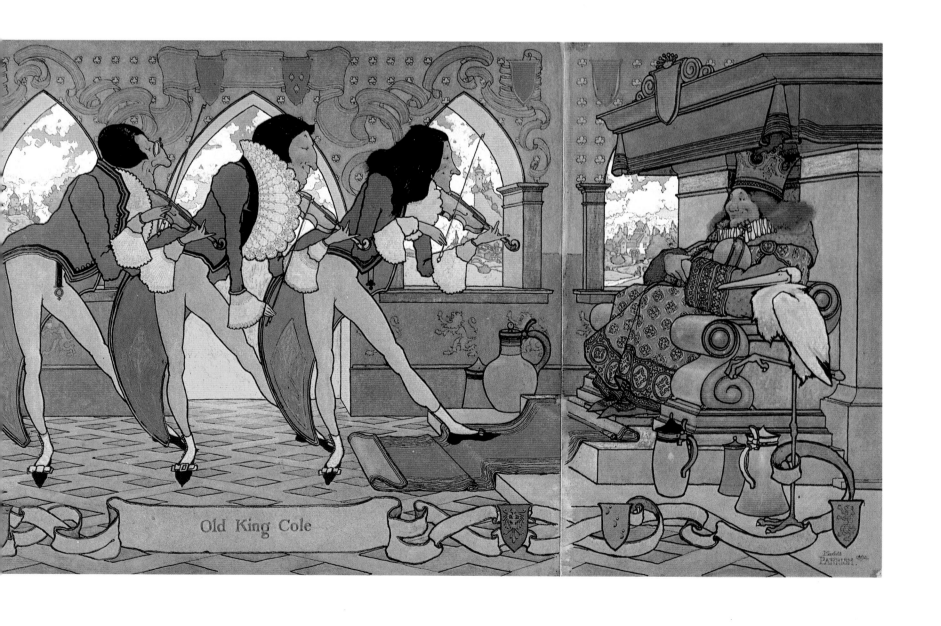
Old King Cole

INTRODUCTION

Left: Maxfield Parrish in 1896, at the age of 26.

In the 1920s, the works of Maxfield Parrish graced the walls of one out of four American homes. Even today, no one can forget his first experience of seeing, as a child, an art print or a book illustrated by Maxfield Parrish. The unique world of fantasy and romance he created in his illustrations strikes modern viewers with no less power than it did nearly a century ago, when Parrish first became known to the public.

Parrish created precise images culled from an incredibly fertile imagination. His use of color was so pure that his colors often came straight from his tubes of paint. (Even today, cobalt blue is often referred to as "Parrish Blue.") To create his works Parrish made photographs of costumed models, then cut the figures out of the photos and arranged them on a canvas or a board. Sometimes he projected the photos so that he could lay them out according to the design theory of geometric harmony known as Dynamic Symmetry. The combination of these and other techniques became his "system." The work that resulted stands forever, unique and strong, documenting a rich fantasy world never equalled before or since.

Frederick Parrish was born in Philadelphia, Pennsylvania, on July 25, 1870, the only child of Stephen and Elizabeth Bancroft Parrish. (Later, as Fred embarked on his artistic career, he assumed his paternal grandmother's maiden name as his middle name, and became known professionally as Maxfield Parrish.) The family traces its lineage to Captain Edward Parrish of Yorkshire, England, who, after a long seafaring career, was appointed the surveyor-general of Maryland. At one time Captain Parrish owned some 3,000 acres of land upon which the city of Baltimore now sits. The members of the Parrish family became prosperous property owners as well as accomplished professionals.

Stephen Parrish (1846-1938), Maxfield's father, was the second son of Dillwyn and Susanna Maxfield Parrish, religious Quakers who had been active in the antislavery movement. Stephen, the first artist in the family, painted *Rain on the Lilla Rush Kill* at the age of 23. He signed it "Step. M. Parrish," using the middle initial "M" to give his name a melodious sound.

In 1877 Stephen took his family to France, and the trip made a great impression on seven-year-old Fred. His imagination came alive as he meandered down European lanes picturing dragons and hobgoblins, and spirits lurking among the gargoyles high up on the medieval cathedrals.

By 1883 Stephen was recognized as one of the greatest etchers in America, along with James A. McNeill Whistler and Charles A. Platt. Secure with his status as an artist, Stephen once again took his wife and son to Europe, only this time it was for two years. The precocious Fred visited museums and studied classical art. During the second summer, he caught typhoid fever and nearly died. While he convalesced, his father took the time to teach his young son to etch and draw. These lessons were an inspiration for Fred to become an artist in his own right. Stephen also encouraged him to watch other artists

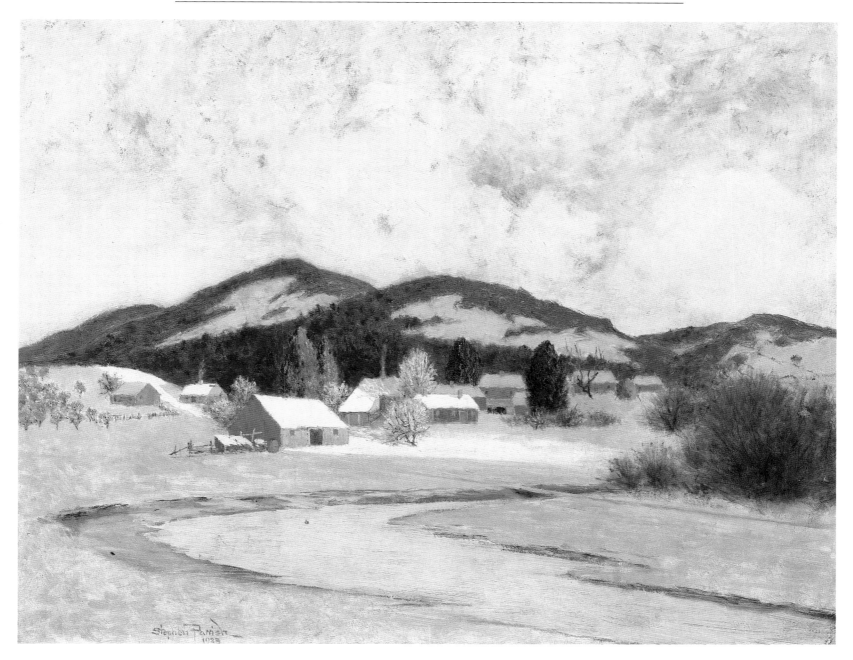

copying paintings of the van Eyck brothers, Rembrandt, Botti-celli, Titian, and other Old Masters. While observing the complicated techniques of the accomplished copyists, he became fascinated with the egg tempera and glazed layers of varnish as well as the arduous process of applying single coatings of a color, one layer at a time.

Fred was particularly drawn to such contemporary English artists as the Pre-Raphaelite Dante Gabriel Rossetti, and Frederic, Lord Leighton, perhaps because of the romantic subjects they painted, such as princesses and saints. This exposure ultimately shaped Parrish's artistic vision, and certainly contributed to the creation of his curious mixture of naturalism, romanticism and fantasy.

Interestingly, one of Lord Leighton's most significant paintings is that of his companion Dorothy Dene, who later became a stage actress. She was an uneducated Cockney girl who modeled for the high-living Victorian bachelor in London. Although Lord Leighton had consistently denied rumors of a romantic relationship with Dene, there was little doubt that one existed between them. Parrish was captivated by Lord Leighton's art, his lifestyle, and the stories of the artist who had an infatuated young model adoringly posing for him.

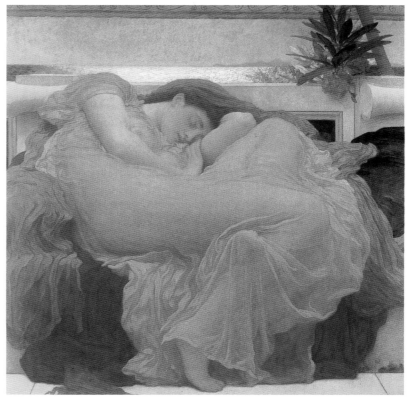

Top: Stephen Parrish's *East of Plainfield, NH,* 1923.

Above: Frederic, Lord Leighton's *Flaming June,* 1895.

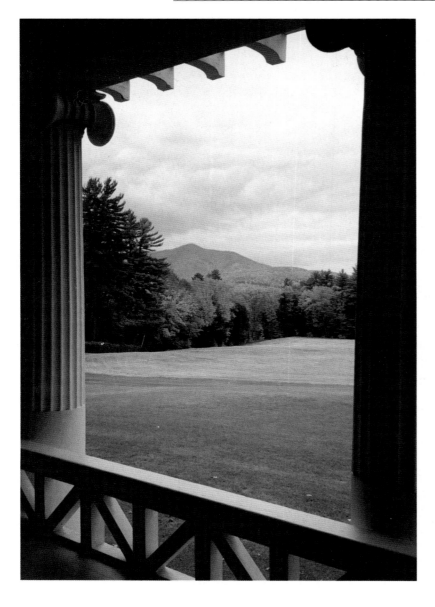

In 1888 Fred Parrish enrolled in the Class of 1892 at Haverford College and matriculated in architectural technology. He was immediately attracted to classical forms and enjoyed building the requisite architectural models in the school shops. As an architectural student, he soon realized that clients could impose mundane constraints upon the creative mind. This, along with the strict Beaux-Arts training, newly formed building codes, and chemistry courses, combined to make the study of architecture – once the noblest of professions – artistically restraining and unattractive to him. After three grueling years, young Parrish did something that was virtually unheard of in the 1890s – he dropped out of college.

While Fred was still struggling with the prospect of architecture as his profession at Haverford, his parents left Philadelphia to visit the artists' colony in Cornish, New Hampshire, founded by their friend, the sculptor Augustus Saint-Gaudens. They saw the wonderful countryside with mountainous backdrops reminiscent of Tuscany and sensed the camaraderie among the artists who had gravitated to the area, and they decided to stay. Stephen commissioned the Philadelphia architect Wilson Eyre, Jr. to design a manor house, called "Northcote," complete with custom furniture and elaborate formal gardens.

During the summer of 1893, as the finishing touches were being applied to "Northcote," Stephen took his son to another artists' colony, on the Annisquam River in Gloucester, Massachusetts. In the studio they shared, Stephen encouraged and instructed his talented young son. Fred, now enrolled at the Pennsylvania Academy of Fine Arts, began to paint his first truly artistic work, *Moonrise*. When he returned to the Academy, he had his first showing of that painting at the Philadelphia Art Club.

As unique as his painting style became, so were his brief but descriptive one-word titles. Other artists and illustrators of the day traditionally used full sentence titles. One can envisage Parrish thinking, "the word identifies the image and the image speaks for itself." The one-word title *Moonrise* was, in a sense, a prototype. Most of Parrish's subsequent titles also tended to be single words, such as *Daybreak, Hilltop, Stars, Enchantment, Dreaming, Contentment, Morning,* and so on.

The Pennsylvania Academy of Fine Arts was a momentous step on Parrish's way to becoming an illustrator. The Academy expanded his knowledge from the intuitive to the professional. He learned concepts of bold color and photography at the Academy under the painter, Thomas P. Anschutz. Anschutz was a realist painter committed to craftsmanship, the use of photography and to scientific color theory (he consistently experimented with unmixed colors). Anschutz also used photographs as studies for paintings and promoted this technique to such students as Charles Demuth, John Marin, Everett Shinn and Charles Sheeler. Parrish immediately saw the opportunities that photography afforded the artist, and used it throughout his career.

From his brief exposure to Howard Pyle he learned to use historic subject matter and costumed models, and developed a desire for a career in illustration. Pyle was the most famous illustrator in the country at the time and was the vital force behind what later became known as the "Brandywine School." Like Parrish, Pyle was a Quaker and a man with convictions. He saw no difference between the fine arts and the art of the illustrator. The students lucky enough to attend Pyle's courses boasted great talents. Some of them, including N. C. Wyeth, Harvey Dunn, Frank Schoonover, and Jessie Willcox Smith, became the superb illustrators of the next generation of illustrators.

Parrish was an audit student of Pyle's at the Drexel Institute. Accounts differ as to how long Parrish attended Drexel, but this recently discovered Parrish letter clearly answers the question: "I was in his class at the Drexel Institute for only a winter and did not have the chance to get to know him as well as members of his class. . . . It was not so much the actual things he taught us as contact with his personality that really counted."

Parrish quickly realized that the use of historic subject matter captured the sentiments of the print audience. He also learned that there was an immediate demand for illustrators and that such a profession was a means for recognition and immediate reward. Additionally, Pyle gave a special class which attracted Parrish: "Drawing From the Costumed Model." Apparently

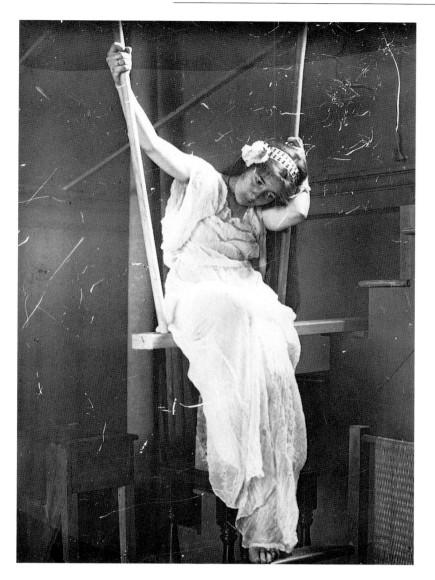

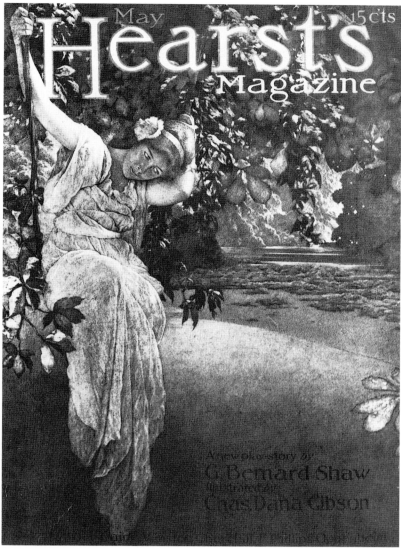

Opposite: A view of the Cornish, New Hampshire, countryside from "Aspet," the home of sculptor Augustus Saint-Gaudens. Parrish moved to Cornish in 1898, and remained there his entire life.

Above: Parrish took this photograph of his favorite model, Susan Lewin, posing for *Reveries* in 1913.

Top right: Parrish's work *Reveries* on the May 1913 cover of *Hearst's Magazine*. The cover was not published.

Left: Howard Pyle's *The Soul of Mervisaunt*, which appeared in the April 1911 issue of *Harper's Monthly*. Pyle was the most famous illustrator in America when Parrish audited his class.

this class inspired Parrish to use his wife, Lydia, and later his companion, Susan Lewin, as costumed models.

Through the writings and lectures of historian Jay Hambidge, Parrish learned design harmony and balance. Hambidge aroused great interest among artists and architects with his studies of ancient Greek theories based on mathematical analysis of architectural monuments. He called this analysis "Dynamic Symmetry." Using the formula called the "Golden Section," $a/b = (a+b)/a$, an artist could use a series of precisely measured rectangles to create a balanced design. The sides of these rectangles would bear a square-root relationship with their ends. (The analysis of the proportions of the early Greek temples is based upon the study of rectangles whose four sides are equal to the square root of five.) As in all theories based on the "Golden Section," the underlying assumption was that all the aesthetic harmonies and symmetries of nature were based on a single proportional relationship. Dynamic Symmetry, therefore, offered artists a way to capture natural proportions in their works, creating a pleasing sense of balance for the viewer. Parrish laid out each of his paintings according to these mathematical relationships of proportion and harmony. This elaborate system of designing was arduous, and one that only such an analytical and disciplined artist as Parrish could embrace and employ successfully.

A true craftsman, Parrish thrived on every aspect of his work. He painstakingly applied several thin glazes of transparent paint over a white ground, a technique he learned from studying the works of the Old Masters. The layers of paint were like color filters, reflecting the color back to the viewer and giving the surface a luminescent quality.

He had his model, Susan Lewin, make her own costumes derived from historical research, and made his own stage sets so that the photographs he took would be in context. He set up little clusters of rocks on mirrors and took photographs for an inventory of backdrops, keeping a library of glass plate photos for future use, which he projected on painting surfaces for lighting effects. Parrish also often made the frames for his works, using columns and moldings of intricate detail, and made the

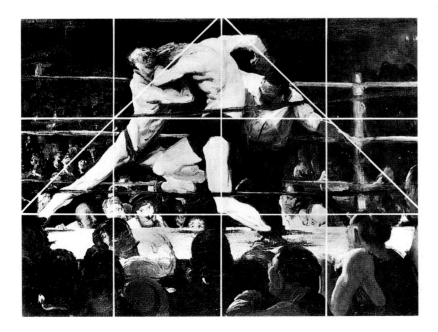

crates in which to ship his works, sometimes decorating the insides with paintings. He even made special labels for shipping, with cartoon characters and graphic designs.

All of the elements of Parrish's art taken together became a "system," a distinctive Maxfield Parrish style, a method which proved to be successful every time he employed it.

In the fall of 1894, upon his return to the Academy in Philadelphia, he was contacted by Wilson Eyre, Jr., his father's architect, and received his first paid commission. Eyre was designing a clubhouse for the Mask and Wig Club, a thespian society at the University of Pennsylvania, and had suggested that Parrish paint a mural. The result, *Old King Cole*, was an immediate success. The club commissioned Parrish for other assignments, including the ornamental decorations on the walls over the members' beer mug pegs. The watercolor study for the mural was later purchased by the Pennsylvania Academy for its own collection in 1895. This piece is notable as the first work Parrish ever sold, and it was one of the first of his works signed "Maxfield Parrish."

The study-sketch of *Old King Cole* was reproduced in *Harper's Weekly* in 1895, and engendered this descriptive narrative: "Maxfield Parrish . . . sends a very clever drawing of a decoration for the club room of the Mask and Wig Club Through the arched openings in the background, one sees a bright green landscape and a sky of brilliant blue, with white,

Opposite top: A detail showing Parrish's signature on his 1895 mural, *Old King Cole*.

Opposite bottom: George Bellows's *Stag at Sharkey's*, with lines superimposed indicating dynamic symmetry divisions.

Right: For Parrish's first commission, he painted the *Old King Cole* mural for the Mask and Wig Club at the University of Pennsylvania.

Below right: Parrish also painted these decorations for the beer mug pegs at the Mask and Wig Club.

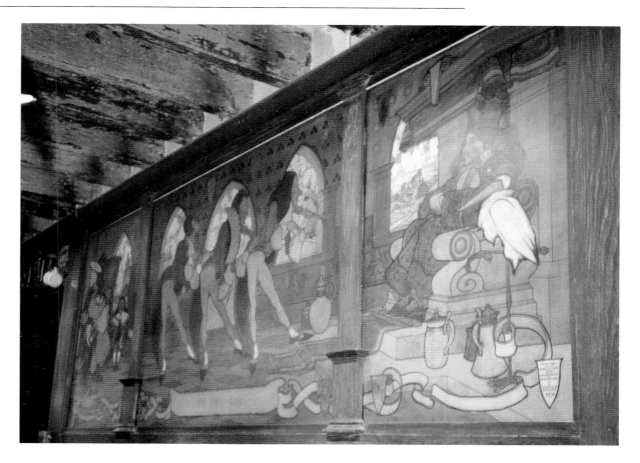

fleecy clouds." Perhaps this was the first critique mentioning his "brilliant blue." The review, and the impact of the work itself upon the viewing public, may be what inspired Parrish to use cobalt blue often in years to come. The so-called "Parrish Blue" ultimately became his hallmark.

During an Academy exhibition in New York, Thomas W. Ball of the Harper and Brothers publishing company saw the study for the Mask and Wig mural. Ball suggested Parrish submit a design for the Easter 1895 edition of *Harper's Bazar*. Parrish eagerly responded with two possible covers, and the magazine accepted both. At the age of 25, Parrish had been discovered nationally.

Also in 1895, while he audited courses at Drexel, Parrish was introduced to an attractive, young art teacher named Lydia Austin (1872-1953). After knowing each other for only a few short months, they married on June 1, 1895. Three days after the wedding he left alone for another art tour of Europe.

When Parrish returned from Europe he found his career had been launched by the *Harper's Bazar* cover. Lydia soon realized her own career as a budding artist was taking a back seat to the creative genius whom she had married. The next few years for Maxfield were a roller coaster of work efforts with art openings, newspaper articles, prizes, more commissions and the national limelight. He spent less and less time with Lydia.

In 1896 Parrish completed his painting *The Sandman*, which was exhibited at the Society of American Artists the following year – his first truly public exhibition of a work. So notable was the success of this painting that in 1897, on the basis of this work, he was admitted into the Society of American Artists. To Parrish this was a great honor; it signified talent beyond that simply of a commercial artist.

In 1897 he completed his first book illustrations, for Lyman

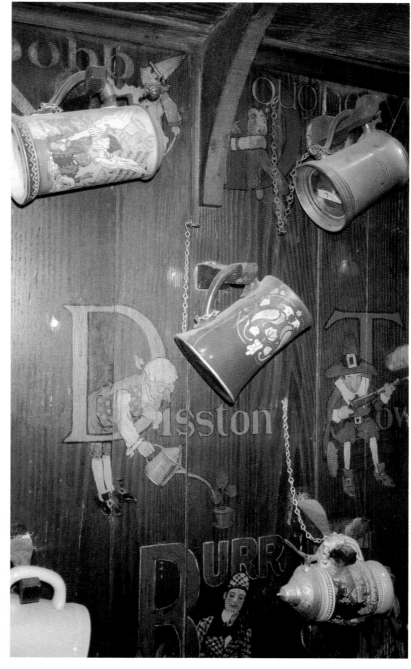

Frank Baum's *Mother Goose in Prose*. The response to his imaginative work was enthusiastic. Book illustration commissions rolled in like thunder thereafter.

In 1898 Parrish decided to move "up to Cornish" to be near his parents. Unfortunately, Stephen and Elizabeth separated shortly thereafter and his mother left for an experimental living commune in Pasadena, California, never to return again. For Parrish, an only child with a deep love for his parents, their separation was earthshaking, and he apparently had a nervous breakdown.

In March 1898 Maxfield and Lydia left Philadelphia for Cornish, where he stayed for the next 68 years. Still preoccupied with architecture, he personally designed and supervised the building of their home, which he called "The Oaks." The house started out quite small, but as it was built, Maxfield got caught up in the excitement of "playing architect" and it grew to 15 rooms. "The Oaks" was praised in the renowned magazine, the *Architectural Record* for its unusual design and craftsmanship. As his family grew and his needs changed, he enlarged "The Oaks" to a grand 20 rooms with several outbuildings, and added a nine-room building as his studio.

When he had recovered from his breakdown, Maxfield dove into his fantasy world with renewed vigor and enthusiasm. He held a one-man exhibition at the Keppell Art Gallery in New York, where his paintings sold well. He next worked on a commission for another book, Kenneth Grahame's *The Golden Age*, and it too was a great success. Published simultaneously in New York and London, it came under the critical eye of German-born art critic Hubert von Herkomer, who wrote: "Mr. Parrish has absorbed, yet purified, every modern oddity, and added to it his own strong original identity. He has combined the photo-graphic vision with the pre-Raphaelite feeling. He is poetic without ever being maudlin, he has the saving clause of humor. He can give suggestions without loss of unflinching detail. He has a strong sense of romance. He has a great sense of characterization without a touch of ugliness. He can be modern, medieval, or classic."

By 1900 there were many artists and intellectuals in full-time residence at Cornish and the neighboring town of Plainfield. The whole area, including nearby Windsor, Vermont, had come to be known as "Cornish." The Cornish colony (or the "Cornish Circle," as it was also known) was often the topic at

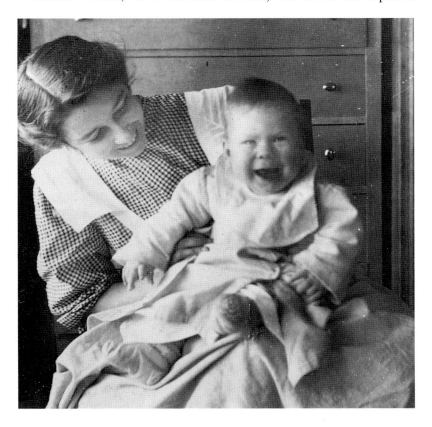

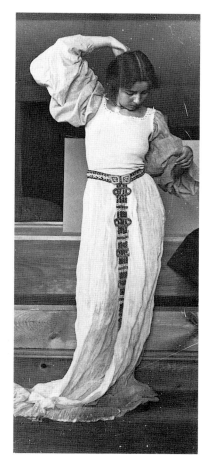

the "right" dinner parties during the height of the New York social season. The Cornish atmosphere was one of culture and artistic endeavor.

It was at this time of great activity, when Parrish had received new book commissions and major magazines clamored to capture Parrish's brushwork for their covers, that he fell ill with tuberculosis. The customary way to recover was to take rest for a period in a climate known for the "cure." In late 1900, at his doctor's request, he went to Saranac Lake in the Adirondack Mountains, and then, in 1901, to Castle Creek in Hot Springs, Arizona. The environment in Arizona was distinctly different from any he had known before. The natural landscape, the colors, and the ghostly quality of light at sunset, for which the Southwest is famous, captivated him. His work became even more luminescent and colorful as a result of his stay in Arizona.

During his recuperation at Hot Springs, Parrish completed his "Great Southwest" series for *Century* magazine. Then, early in 1903, he was offered an assignment in Italy to illustrate Edith Wharton's *Italian Villas and Their Gardens*. Off he went again, brush in hand, returning in March.

The Parrishes' first child, (John) Dillwyn, was born on December 1, 1904, nine months and six weeks after the Parrishes returned from yet another trip to Italy. Dillwyn was followed by Maxfield Jr. (1906), Stephen (1909), and a daughter, Jean (1911).

Shortly after Dillwyn's birth, Parrish, facing overlapping book and magazine commission deadlines and feeling quite imposed upon at "The Oaks," went to his father for advice. Stephen suggested two things and his son embraced them both. The first was to hire help around the house to assist Lydia with

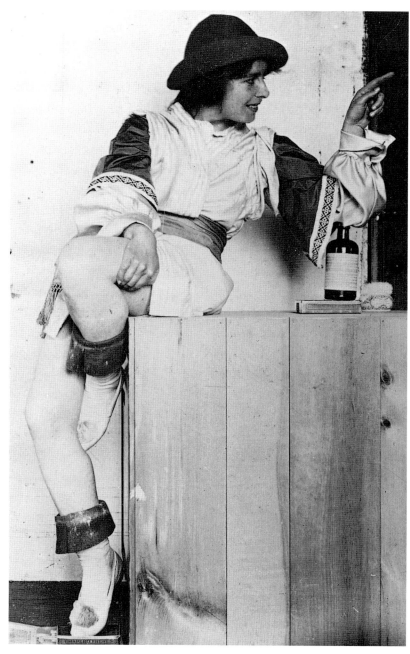

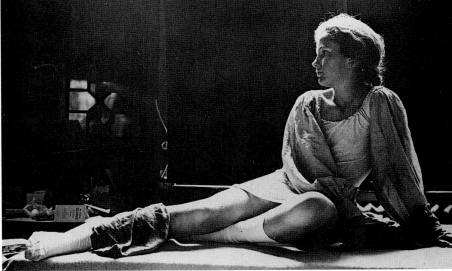

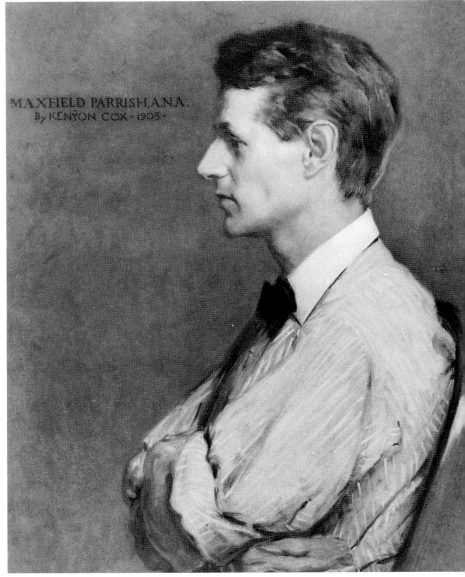

the housework and the baby. Stephen recommended the niece of his own housekeeper Margarite Lewin, a pretty 16-year-old named Susan Lewin. She was hired in 1905. The elder Parrish also suggested that Maxfield build himself a separate studio – this would give him the solitude he needed to work, and would be large enough to accommodate mural-size canvases.

Soon after he hired her, Parrish asked Susan Lewin to model for him. That first pose resulted in the painting entitled *Land of Make-Believe.* He was so happy with the outcome that he began to use her as his constant model. Eventually, he and Susan moved into his studio building at "The Oaks."

Lydia, unhappy and not liking the New Hampshire climate, began spending her winters in Georgia in 1909. She plunged herself into a new career pursuit as chronicler of the African-Americans of St. Simons Island. By 1942, after more than 30 years of research, she published a tome entitled *Slave Songs of the Georgia Sea Islands.*

Maxfield and Lydia's relationship was strained when they were together, and seemed to function best when they were apart. Nevertheless, it is true that the Parrishes kept up a good front and that Maxfield respected Lydia very much. But it is also true that he lived for more than 40 years in the studio building at "The Oaks" with his companion/housekeeper/model, Susan Lewin.

A country girl without a high school education, Susan Lewin was quite stunned by the effete social setting of Cornish. Parrish, reminiscing about the life of Lord Leighton, recognized that Susan was clearly a counterpart for Dorothy Dene. Later he posed Susan for *Sleeping Beauty* in much the same position as Leighton had painted Dene some 17 years earlier.

Parrish worked with other female models, but Susan was always his favorite. For younger girls, he occasionally enlisted his daughter Jean and her good friend, Kitty Owen, the grand-daughter of William Jennings Bryan. He also used the two pretty daughters of Judge Learned Hand, another Cornisher. Several young boyfriends of Susan's often called at the kitchen door, among them Kimball Daniels and Earle Colby. In 1905 Parrish painted young Kimball Daniels, and he stands immortalized in *Harvest.*

During this period, Parrish basked in the limelight, while Lydia bravely entertained celebrities at "The Oaks" during the summers. As Cornish developed into the cosmopolitan play-ground of artists and intellectuals before the war, Susan Lewin also developed. She became indispensable and grew more competent and sure of herself in dealing with the public, the media and with notables who called at "The Oaks." Susan ultimately decided who was permitted in and who was not. She continued to serve Parrish as a model, to serve his meals, and eventually assisted him with his work.

Opposite top left: Parrish's photograph of Susan Lewin posing for *Sleeping Beauty* in 1912.

Opposite top right: In addition to Susan Lewin, Parrish used his daughter Jean as a model.

Opposite below: A 1905 portrait of Maxfield Parrish by his friend and fellow Cornisher Kenyon Cox.

Right: Parrish's work adorned many magazine covers. *Christmas Number – The Boar's Head* appeared on the cover of *Collier's* on December 16, 1905.

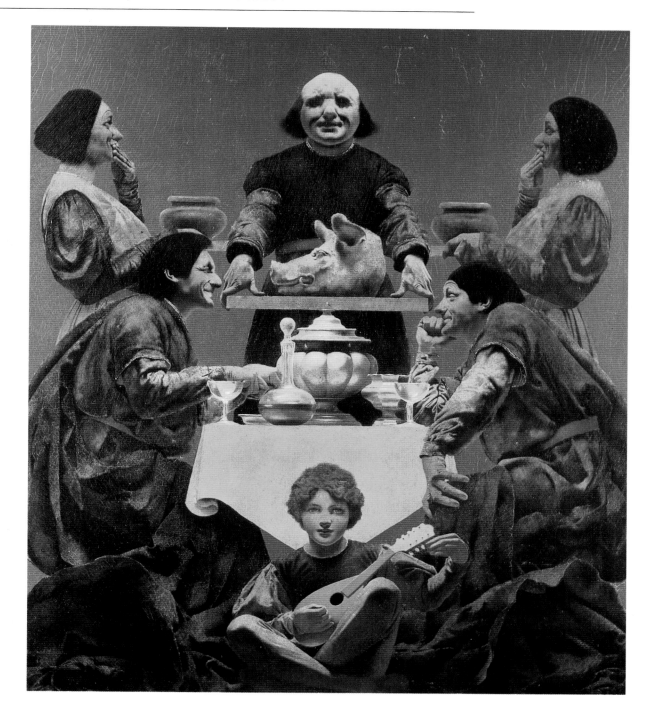

By the early 1920s, the Cornish art colony had accrued an incredible roster of residents. Each year, as the weather warmed up and the summer residents returned, the social life began anew. Parties at "The Oaks" boasted honored guests such as: Herbert Adams, sculptor; Kenyon Cox, painter and art critic; Thomas W. Dewing, painter; Learned Hand, jurist; Sidney Homer, composer; Paul Manship, sculptor; Robert Paine, technical innovator; Everett Shinn, painter; Charles A. Platt, architect and artist; and many more. The community had become known to the world at large as an "aristocracy of brains."

From 1904 to 1935 Parrish was never at a loss for work. His fame grew and his commissions went up to $2,000 per illustration. In 1904 Parrish accepted an exclusive magazine contract from *Collier's* which lasted seven years. The substantial fee was one reason that he took the commission, but the other was that *Collier's* was a large format magazine (9 × 12 in.), and those dimensions would give him greater freedom to experiment with his designs. Ten years later he executed a number of covers for the humor magazine *Life*, and these varied considerably from

his *Collier's* work. Other periodicals that had their covers adorned with Maxfield Parrish illustrations included *Scribner's*, *Harper's Weekly*, *Century Magazine*, and the *Ladies' Home Journal*.

Until the mid-1920s, he also illustrated several books. His last and best, published in 1925, was *The Knave of Hearts* by Louise Saunders. His advertising work included displays, billboards, print layouts, package designs, and even product endorsements. His Dutch Boy illustration was almost a trademark for Colgate products, and he completed many assignments for Jell-O, Fisk Tires, Swifts Premium Ham, Hires Root Beer and Djer-Kiss Cosmetics. For each year between 1918 through 1934 he painted works for the Edison Mazda Division of General Electric. These paintings were used as calendar illustrations and made their way into countless American homes, making Parrish's style known to an even wider audience. This plethora of superb works made "Parrish" a household name, and his work soon became easily recognizable to the American public.

During the course of his career Parrish received honors from such organizations as the National Academy of Design (1906),

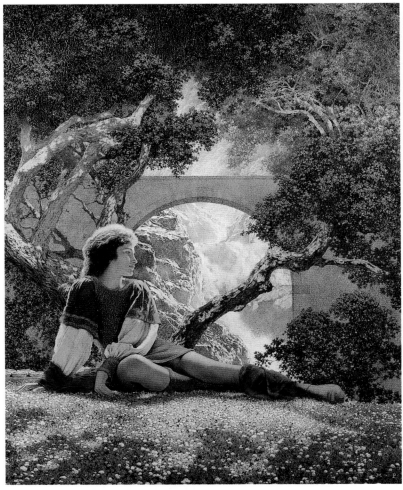

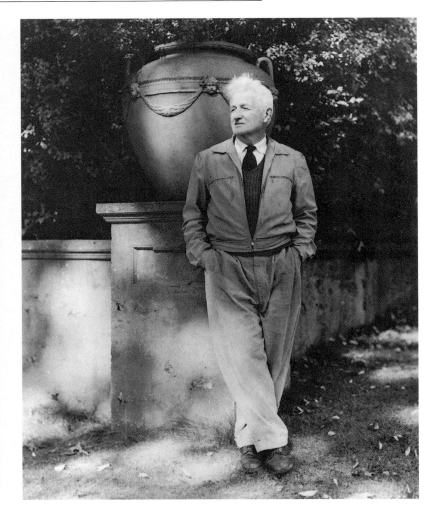

Above: Parrish's *The Knave*, one of several works for the book *The Knave of Hearts*, 1925.

Below: A detail from *Daybreak*, 1922. Parrish's daughter Jean was the model.

Above: Maxfield Parrish in the garden at "The Oaks" in 1957.

Opposite: Maxfield Parrish at the age of 86.

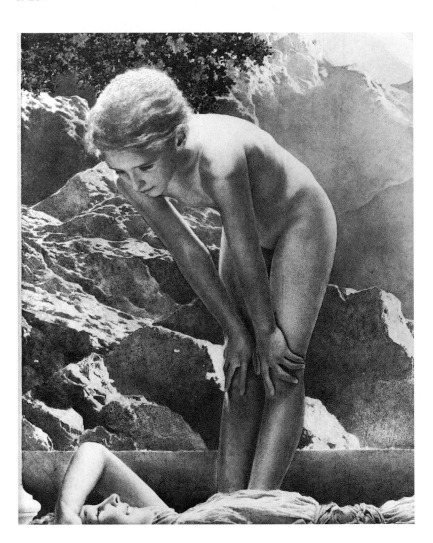

Phi Beta Kappa (1908), and the Architectural League of New York (1917). He also received an honorary degree from Haverford College in 1914.

As his commission rates soared, Parrish was characterized in print as the "businessman with a brush" for his acumen in striking good deals with publishers and printers. In everything he did he exploited the fiscal possibilities. Most intriguing was his manner of handling commissions. He would paint the desired picture and sell the client the rights to a one-time use only. He would then sell the reprint rights for an ongoing percentage royalty fee, and then sell the actual painting to a collector-admirer. In other words, he sold the same work three times.

Parrish's involvement with art prints began in 1915, when Clarence A. Crane of Crane's Chocolates commissioned him to design a candy box cover. The success of this project opened a new direction for his career. In 1916 Crane hired Parrish to do an illustration for the company's Christmas gift boxes. Crane offered his customers the opportunity to buy a reproduction of the painting. The response was overwhelming. Consequently, each candy box contained order blanks. Parrish did other very successful paintings for Crane's including the famous *Garden of Allah*. It was this experience that made him realize that he could liberate himself from the rigors and stress of production deadlines of advertising and book commissions. He knew that

he not only had a formula for his paintings, but he also now had a formula for financial success.

In 1922 he painted *Daybreak* – which he called, "the great painting" – for the art print publishers Reinthal and Newman – the House of Art, who had distributed the popular *Garden of Allah* for Crane's. This painting became one of the most successful prints of all time, and secured Parrish's position as the country's most popular illustrator after World War I. *Daybreak* had all of the components that Parrish loved best. Using photographs of his daughter Jean and of Susan Lewin, he produced a photomontage to structure the composition according to the precepts of Dynamic Symmetry, and he included some architectural elements, with the proverbial "Parrishscape" in the background. It was Maxfield Parrish at his best.

The *Daybreak* art print was a sensation, and immediately adorned walls throughout middle-class America. By 1925 Parrish's royalties on this print totaled more than $100,000. He then sold the original painting for an unprecedented $10,000. By comparison, the average blue-collar worker was earning about $1,200 a year. The "businessman with a brush" he was, indeed.

After painting three more art prints that were not quite as successful as *Daybreak*, and when he himself had grown tired of some of his subjects, he said in a 1931 interview, "I'm done with girls on rocks. I have painted them for 13 years and I could paint them and sell them for 13 more. That's the peril of the commercial art game. It tempts a man to repeat himself."

By that time, Susan was fading as a model, and the public's love for Parrish was waning. Copyists and imitators had flooded shops and advertisements with Parrish look-alikes, and as the Depression progressed, the public came to consider sentimental themes trite. Parrish had become somewhat passé.

In 1931, at the age of 61, Parrish decided to paint only landscapes, which had always been his passion, from then on. The businessman in him knew that he could sell landscapes, and that his income was secure. He rationalized this decision for a reporter by saying, "My present guess is that landscapes are coming in for magazine covers, advertisements and illustrations. Shut-in people need outlets for their imaginations. They need windows for their minds. Artists furnish them."

In 1935 Parrish signed a contract with Brown and Bigelow Publishing Company of St. Paul, Minnesota, to produce landscape illustrations for calendars, greeting cards and playing cards. By 1936 he completed his last work for a magazine. Two years later his father died at the age of 92. Stephen Parrish had been a landscape painter in his later career, and this may have intimidated Maxfield, keeping him from blossoming as a landscape artist while his father was still alive. Parrish's illustration career, however, had peaked by this time, and the Depression, the popularity of radio, moving pictures and then television had changed Parrish's audience. Thereafter his life was spent in a less hectic way, only painting his beloved landscapes.

Each year from 1936 to 1962 Parrish painted a new landscape for Brown and Bigelow. While previously Parrish had illus-

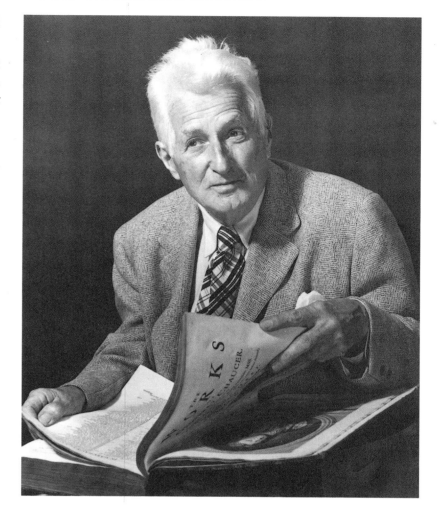

trated fantasy scenes with whimsical creatures in a detailed and realistic manner, now he painted landscapes with real elements juxtaposed from both New England and the Southwest. These iridescent landscapes had a mysterious, unearthly look, perhaps because of the composite use of New Hampshire oaks, Arizona mountains and imaginary waterfalls. Seventeen million calendars, three million greeting cards, and one million prints were distributed, and he received royalties for each and every one of them.

On March 29, 1953, Lydia Parrish died in Georgia. Susan Lewin stayed with Parrish after Lydia's death and most probably thought they would be married. For whatever reason, Parrish did not marry her. In 1960 Susan Lewin, at age 70, married Earle Colby, whom she had known as a girl. She needed her own lifestyle and a companion for her remaining years.

Parrish had painted steadily from his days at Annisquam in 1894 until 1960, when arthritis in his fingers made it hard for him to paint. His declining health (he was 90) and his shock over Susan's marriage prevented Parrish from ever completing another painting.

Yet Parrish lived long enough to see a renewed interest in his art. In 1964 he appeared at various retrospective exhibitions of his work. The next year the most important art museum in the United States, the Metropolitan Museum of Art, purchased *The Errant Pan*. Just ten days after the close of the largest retrospective exhibition of his work, on March 30, 1966, Maxfield Parrish died quietly at "The Oaks" at the age of 95, having lived a full and untortured life.

BOOK ILLUSTRATIONS

Of all of the illustrations that Maxfield Parrish did during his long career, his book illustrations have had the most lasting impact on his audience. Perhaps the most significant effect of Parrish's book illustrations, which were mostly for nursery rhymes and fairy tales, is the enthusiastic reaction they bring out in children. More impressionable than adults, children are particularly responsive to the reinforcement of the visual image by the accompanying text, and to the world of imagination. Consequently, admirers of Parrish illustrations are of long standing and are deeply loyal, because they discovered his work during their youth. The proliferation of reprints has meant that for generations, children have appreciated Parrish's glorious images of fantasy.

Parrish's first illustrated book, L. Frank Baum's *Mother Goose in Prose*, was published in 1897. Its 15 black-and-white illustrations do not fit easily into any historical context. Parrish intended the setting to be anonymous yet wondrous, with goblin-like creatures abounding. After *Mother Goose's* immediate success and its consequent reprinting in editions of various sizes, Parrish received numerous book commissions as publishers clamored for his work.

The bold graphic designs of Parrish's book illustrations lent them to advertisements for the books as well as to posters and to reproduction in magazines. Many of his book illustrations received more exposure and were more successful as art prints. Conversely, many of his book illustrations were first executed as magazine commissions and later consolidated into book form. Still, because books endure while other forms of media do not, Parrish is best known as a book illustrator.

Maxfield Parrish gained wide early recognition from his illustrations for Washington Irving's 1809 historic parody entitled *Knickerbocker's History of New York* (1900). These early illustrative works, in ink and lithographic pencil on textured paper, are characterized by fine contour lines, with a stippled ink technique. They are almost pointillist in style and have rich granular shading. The figures portrayed by Parrish are as satirical visually as Irving's satiric text.

In Kenneth Grahame's book *The Golden Age* (1899) and its sequel *Dream Days* (1902), Parrish moved away from the earlier linear and pure geometrical compositions of *Mother Goose*, towards the photographic illusionism used in his later works.

The Golden Age was so well received and highly acclaimed in Europe that, after reading an enthusiastic review, the German Kaiser Wilhelm II ordered 12 copies for his personal library. *Dream Days* was originally commissioned in color, but at the last minute a new printing process permitted a better quality black-and-white edition. Therefore, the color edition was scrapped. The color plates in this chapter include the first ever color reproductions from *Dream Days*.

Italian Villas and Their Gardens by Edith Wharton (1904), and *Poems of Childhood* by Eugene Field (1904), the first Parrish book published in color, were the results of Parrish's travels in Italy, during which he documented inspiring scenes with his camera and sketchbook. *The Arabian Nights*, edited by Kate D. Wiggin and Nora A. Smith (1909), was the result of illustrations previously published in *Collier's* magazine and then compiled by Scribner's for inclusion in the book. These illustrations were later released as art prints. *A Wonder Book and Tanglewood Tales* (1910) by Nathaniel Hawthorne, and *A Golden Treasury of Songs and Lyrics* (1911) by Francis Turner Palgreave, were well received both by critics and by the public. *A Golden Treasury*, however, irked Parrish because it was published by Duffield and Company without his agreement. Duffield simply reprinted various covers from *Collier's* magazine and issued the book without his input. Duffield's actions caused Parrish to be very careful from that point on with respect to reproduction rights and control over his works. Today, the illustrations from *A Golden Treasury* are among the most coveted by collectors.

Parrish's last illustrated book, *The Knave of Hearts* (1925), was his masterpiece. Written by Louise Saunders, the wife of Maxwell Perkins (the editor of Scribner's and a summer resident in Cornish), it included 26 illustrations executed over a period of three years beginning in 1921. It was first published by Scribner's and Sons in an elegant slipcased edition, and originally sold for the huge sum of $10. Yet the first printing, a magnificent undertaking, was not a commercial success. Perhaps this was due to its large size (14 × 11½ in.) or to its high price tag for the times. From the *Knave* book illustrations, the House of Art later released puzzles, art prints, cards and even several lower-priced editions of the original book. The royalties to Parrish were low, but ultimately he earned over $65,000 from the sales of a few of the original paintings.

Left:
Its Walls Were as of Jasper, 1900
Dream Days by Kenneth Grahame
John Lane: The Bodley Head, 1902
Oil on board, 15 × 11½ in.
Private Collection
Courtesy: The American Illustrators Gallery (LUD 548)

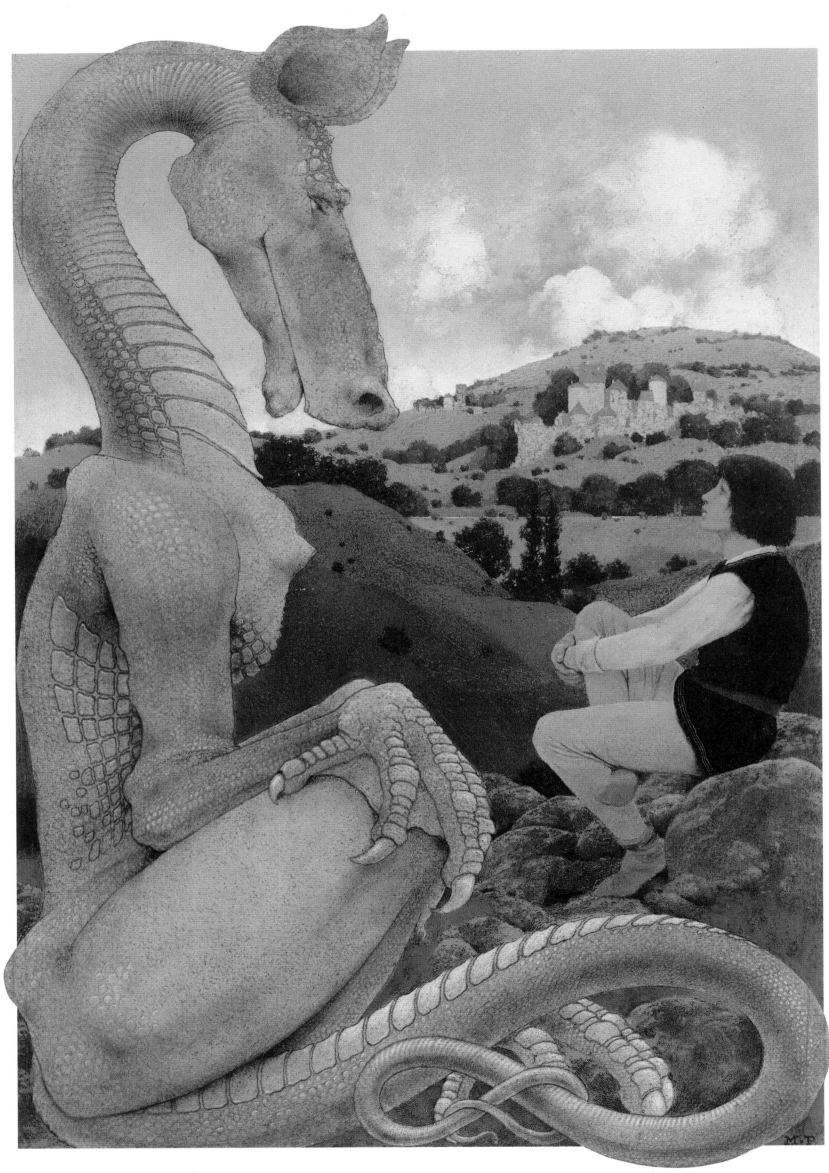

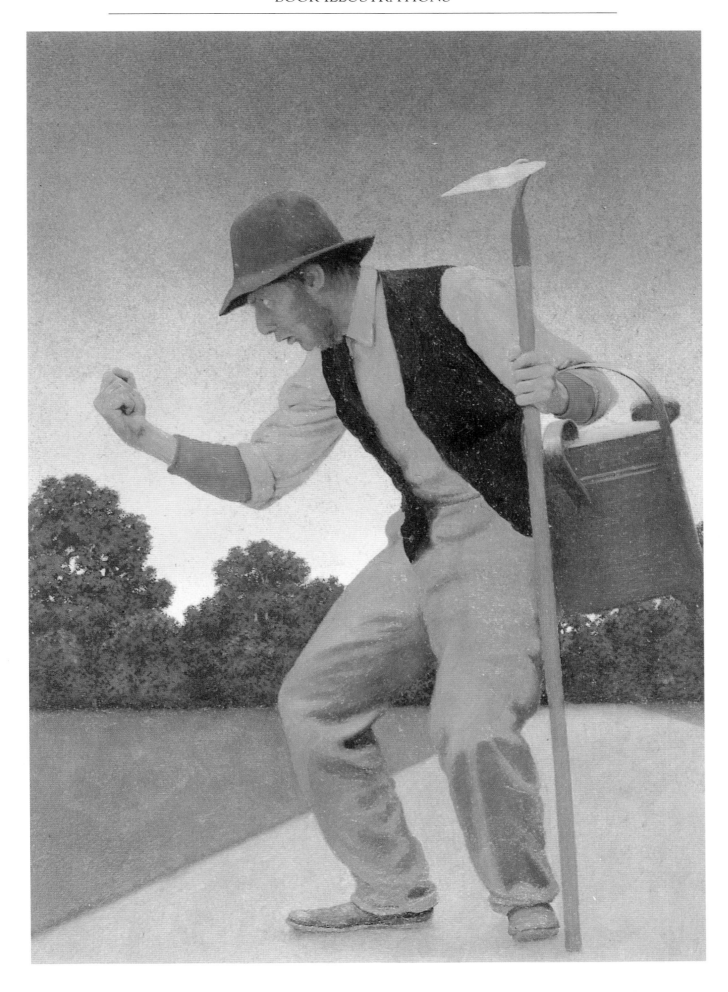

Left:
The Reluctant Dragon, 1900-01
Dream Days by Kenneth Grahame
John Lane: The Bodley Head, 1902
Oil on illustration board, 16¼ × 12¾ in.
Private Collection
Courtesy: The American Illustrators Gallery (LUD 549)

The Twenty-First of October, 1902
Dream Days by Kenneth Grahame
John Lane: The Bodley Head, 1902
Oil on board, 11¾ × 8½ in.
Private Collection
Courtesy: The American Illustrators Gallery (LUD 543)

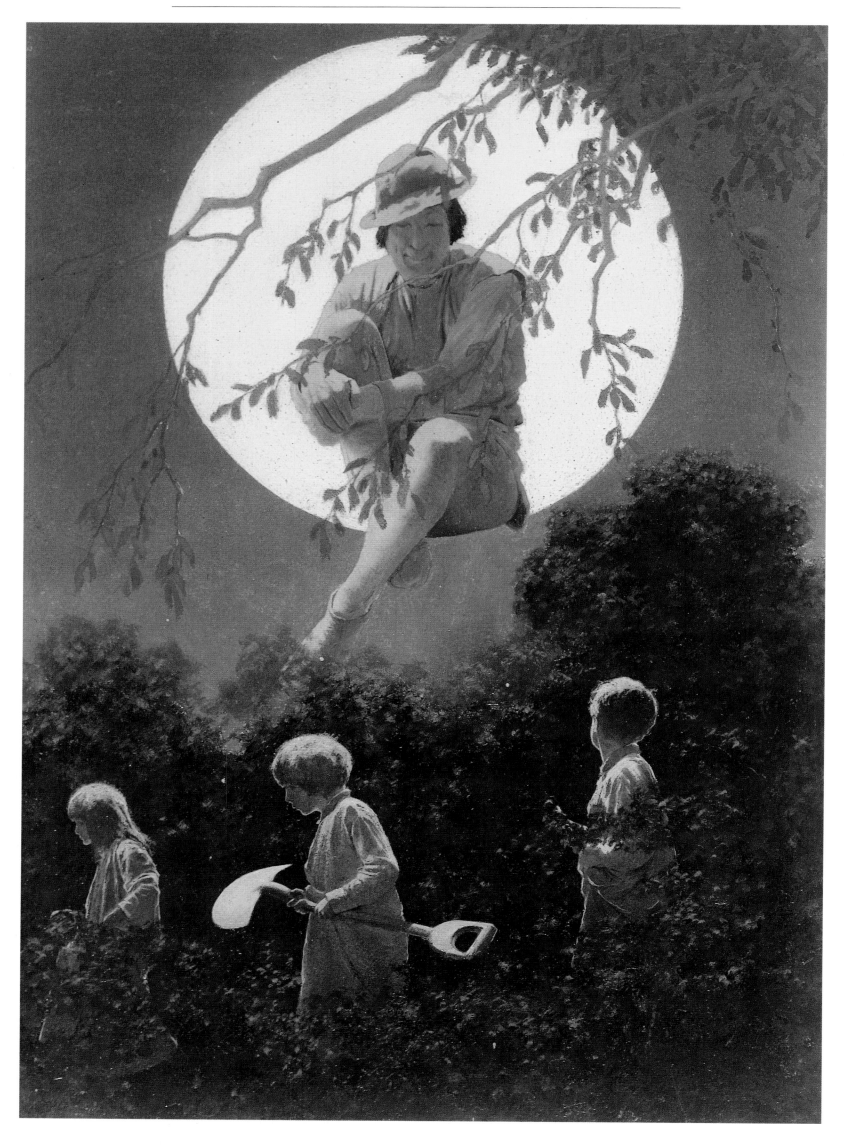

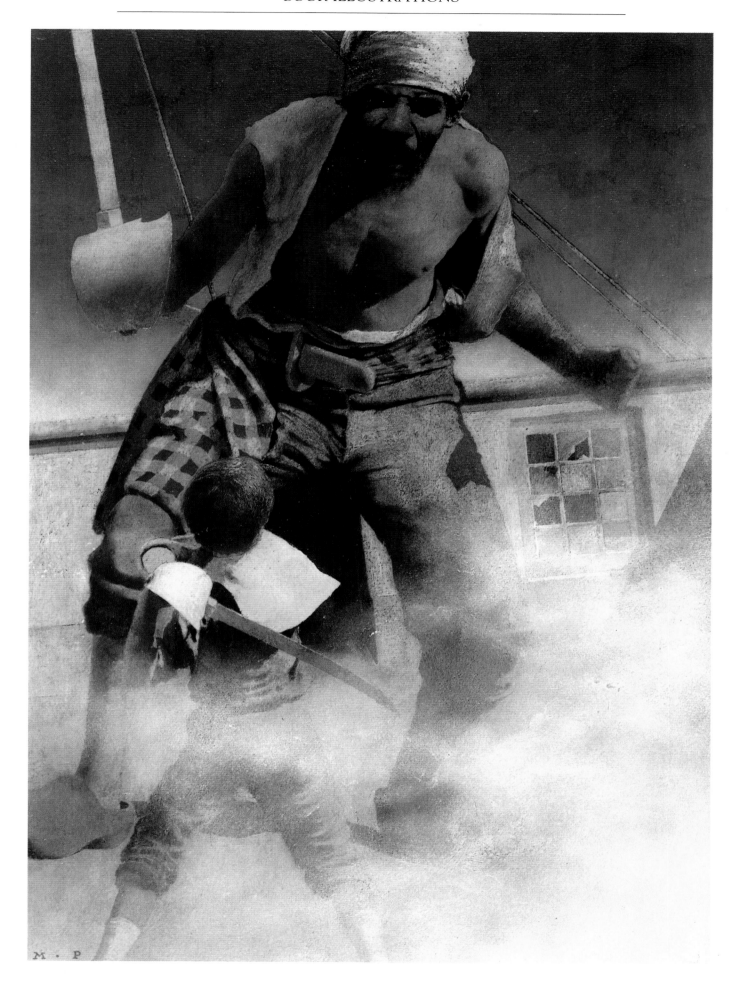

Left:
A Departure, 1902
Dream Days by Kenneth Grahame
John Lane: The Bodley Head, 1902
Oil on illustration board, 15½ × 12 in.
Private Collection
Courtesy: The American Illustrators Gallery (LUD 551)

A Saga of the Sea, 1901
Dream Days by Kenneth Grahame
John Lane: The Bodley Head, 1902
Oil on illustration board, 15½ × 11¾ in.
Private Collection
Courtesy: The American Illustrators Gallery (LUD 298)

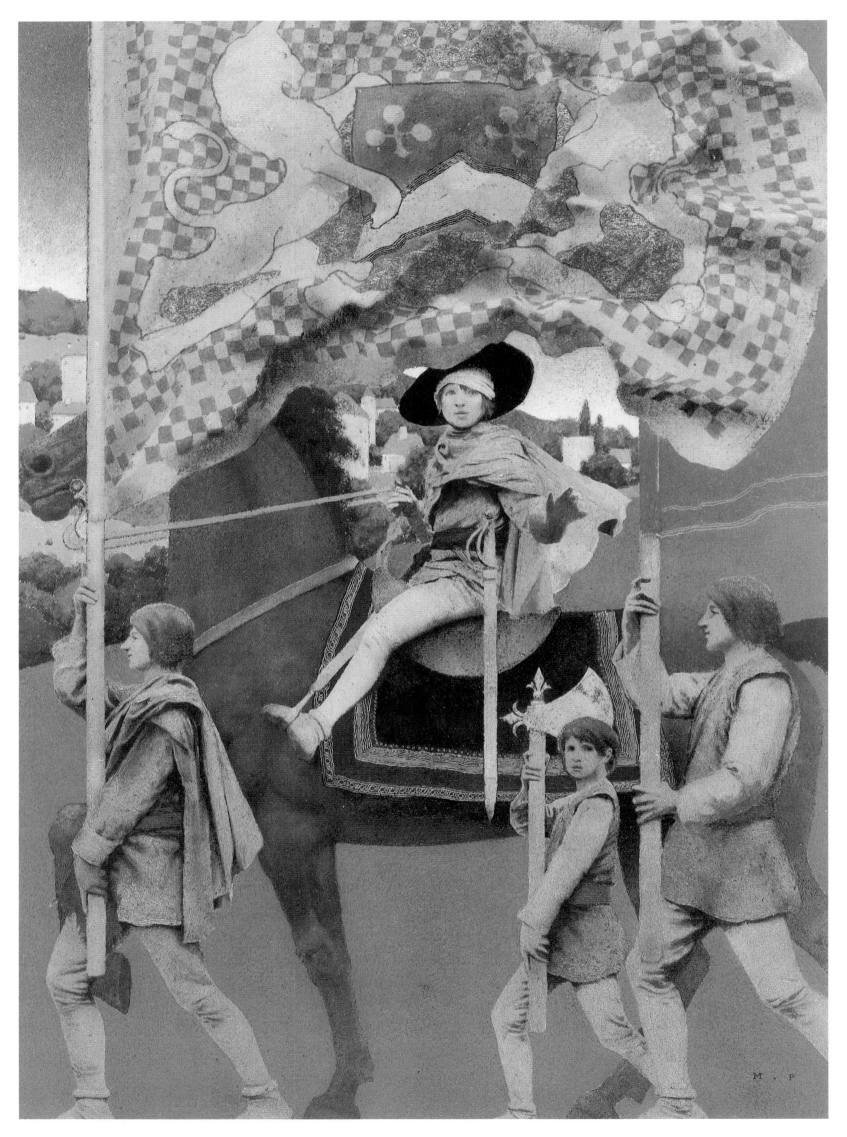

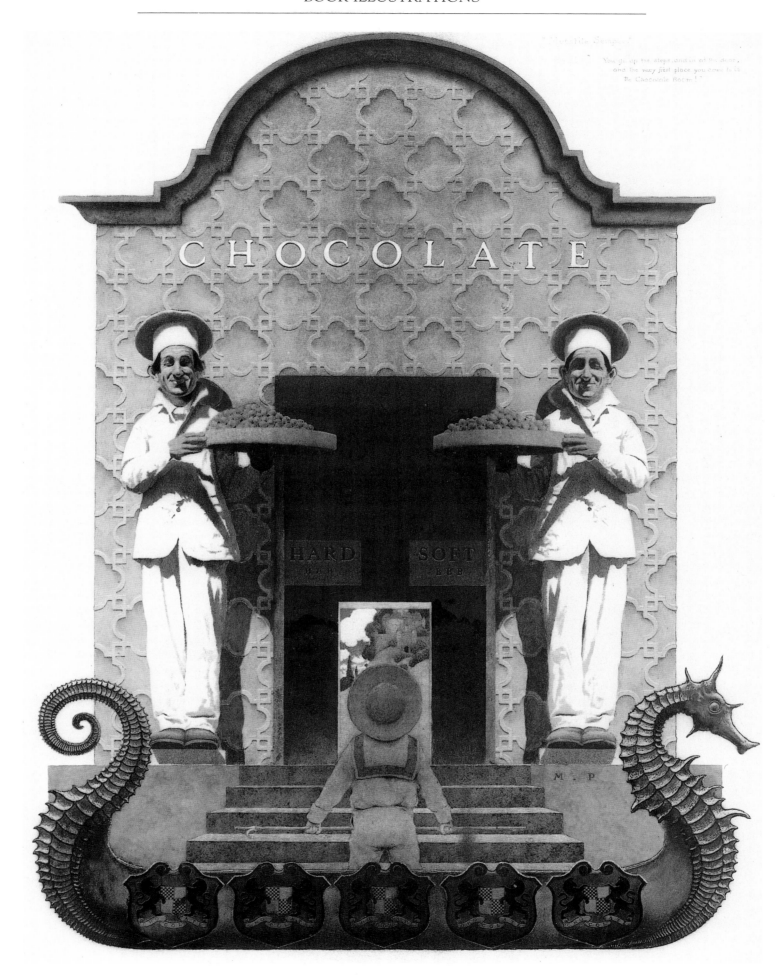

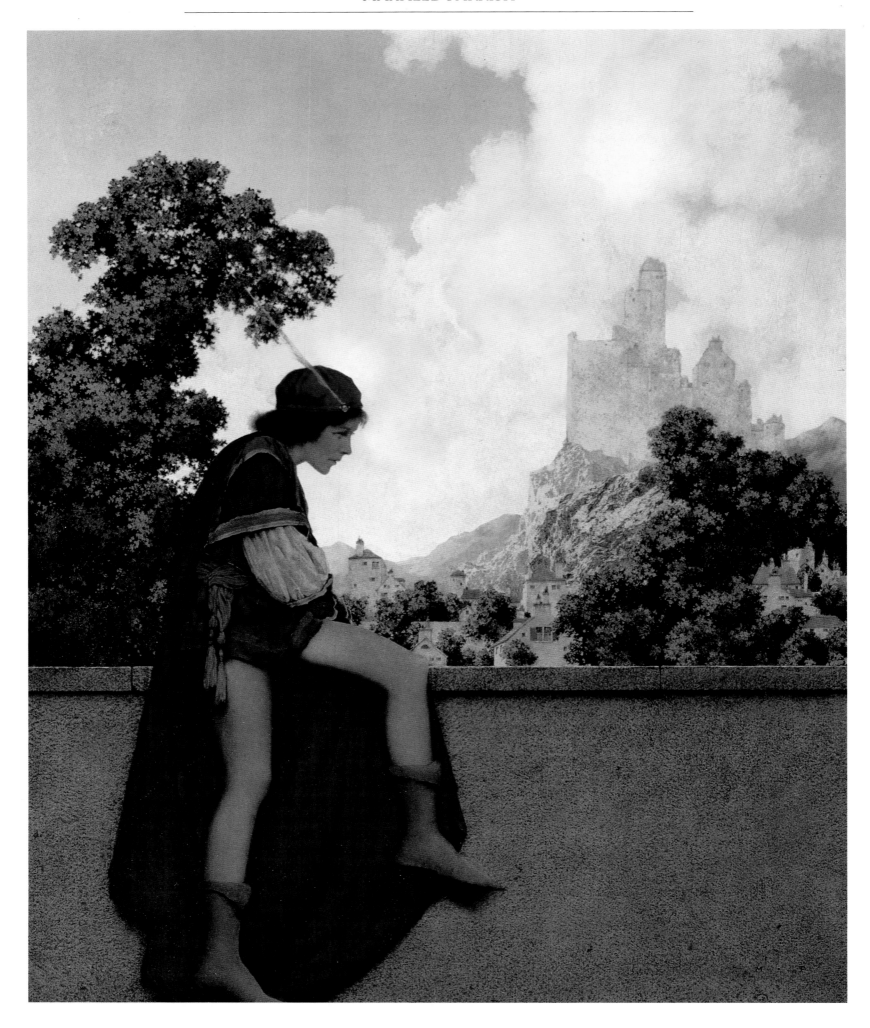

The Knave Watches Violetta Depart, 1924
The Knave of Hearts by Louise Saunders
Charles Scribner's Sons, 1925
Oil on panel, 20⅛ × 16⅜ in.
Private Collection
Courtesy: The American Illustrators Gallery (LUD 713)

Right:
Indian Drinking Rum, 1899
Knickerbocker's History of New York by Washington Irving
R. H. Russell, 1900
Pen, ink and splatter on paper, 12 × 8¾ in.
Courtesy: The American Illustrators Gallery (LUD 213)

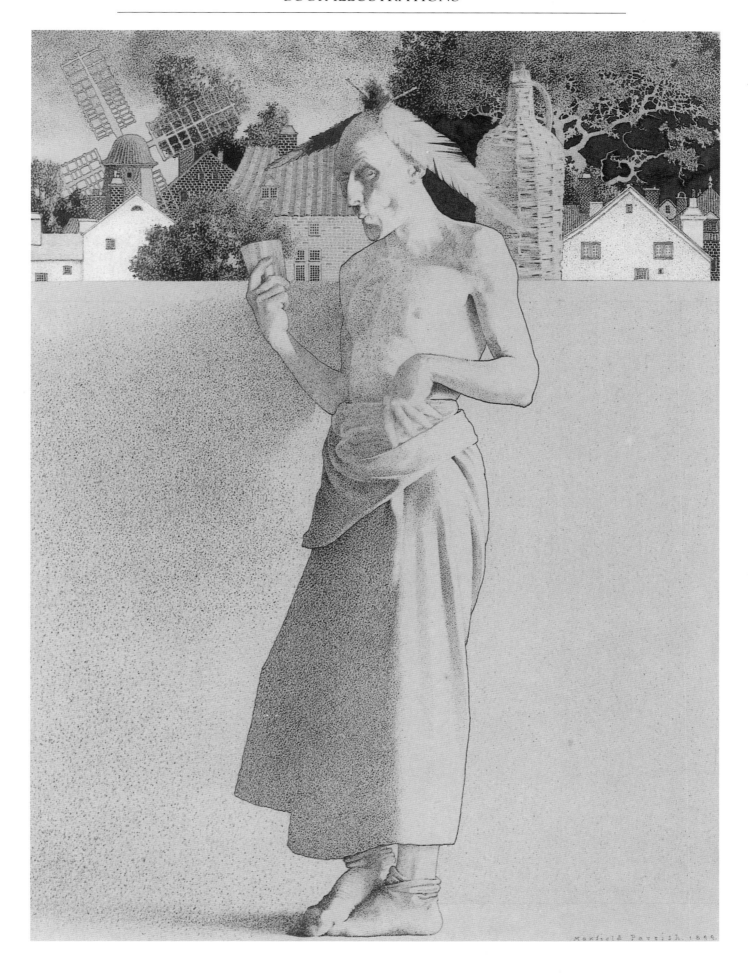

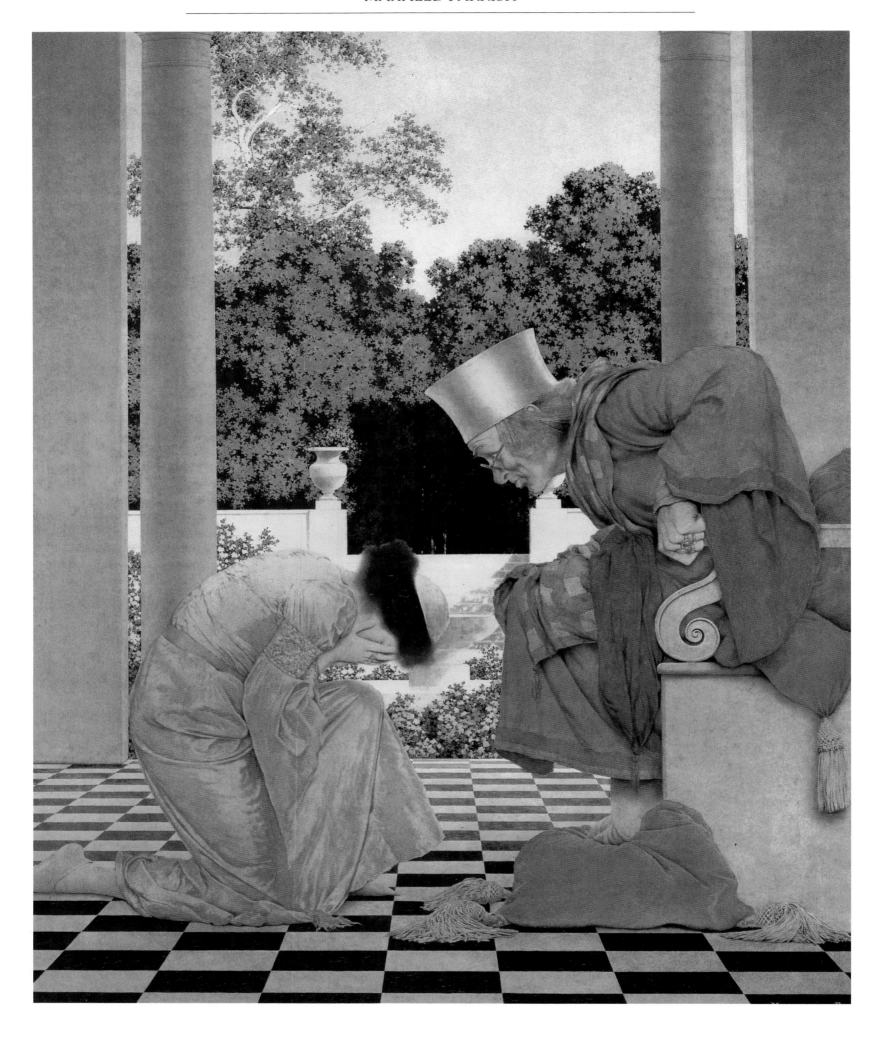

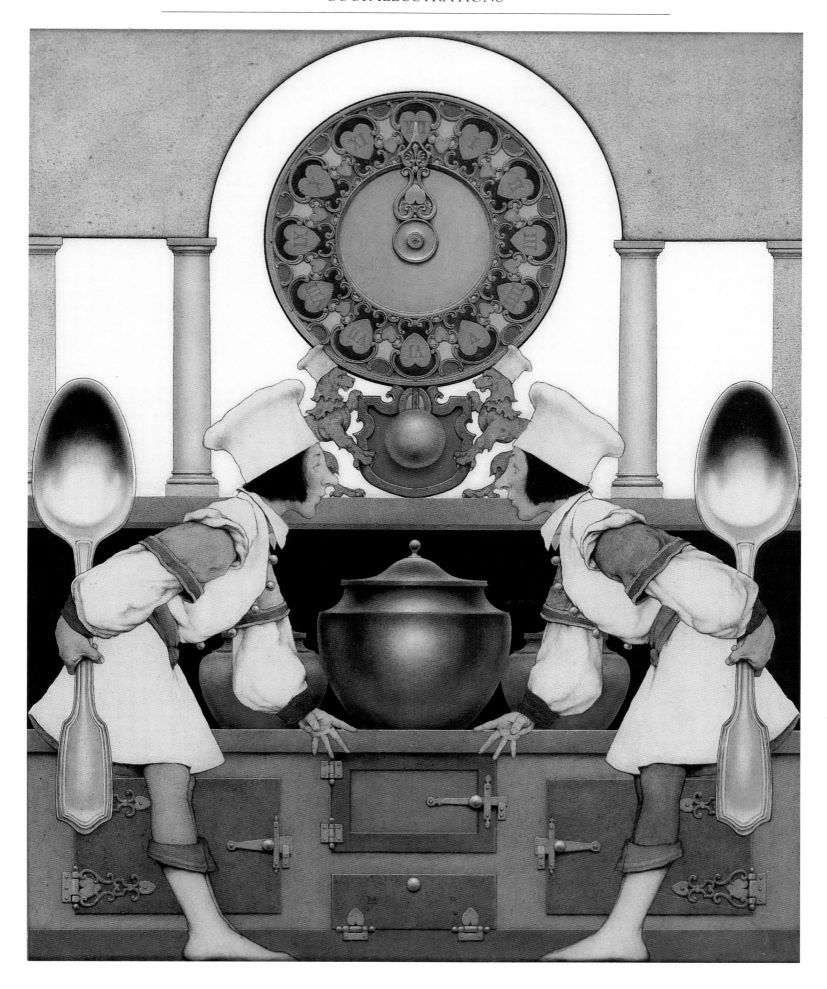

Left:
Lady Ursula Kneeling Before Pompdebile, King of Hearts, 1924
The Knave of Hearts by Louise Saunders
Charles Scribner's Sons, 1925
Oil on panel, 20½ × 16½ in.
Private Collection
Courtesy: The American Illustrators Gallery (LUD 703)

Two Pastry Cooks: Blue Hose and Yellow Hose, 1924
The Knave of Hearts by Louise Saunders
Charles Scribner's Sons, 1925
Oil on panel, 20 × 16 in.
Private Collection
Courtesy: The American Illustrators Gallery (LUD 692)

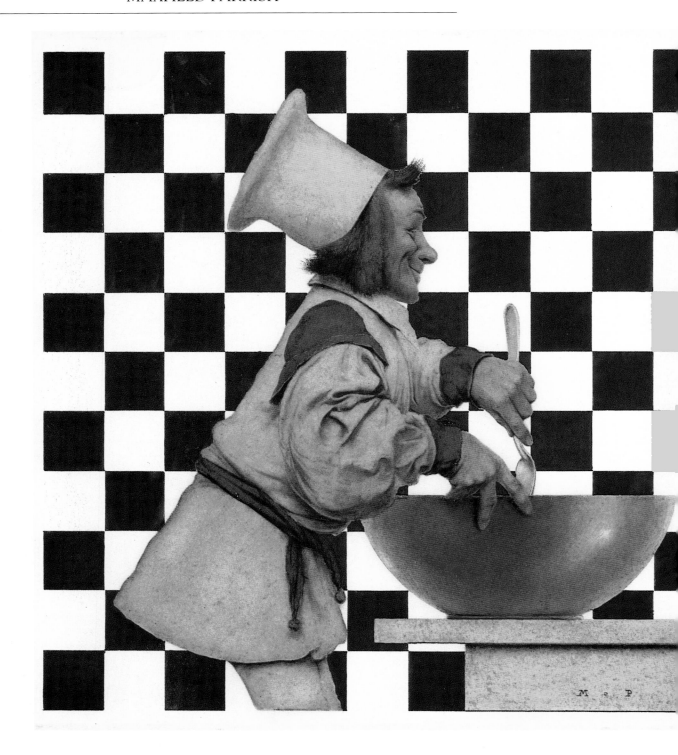

Two Chefs at Table, 1925
The Knave of Hearts by Louise Saunders
Charles Scribner's Sons, 1925
Oil on panel, 9¼ × 20 in.
Private Collection
Courtesy: The American Illustrators Gallery (LUD 700)

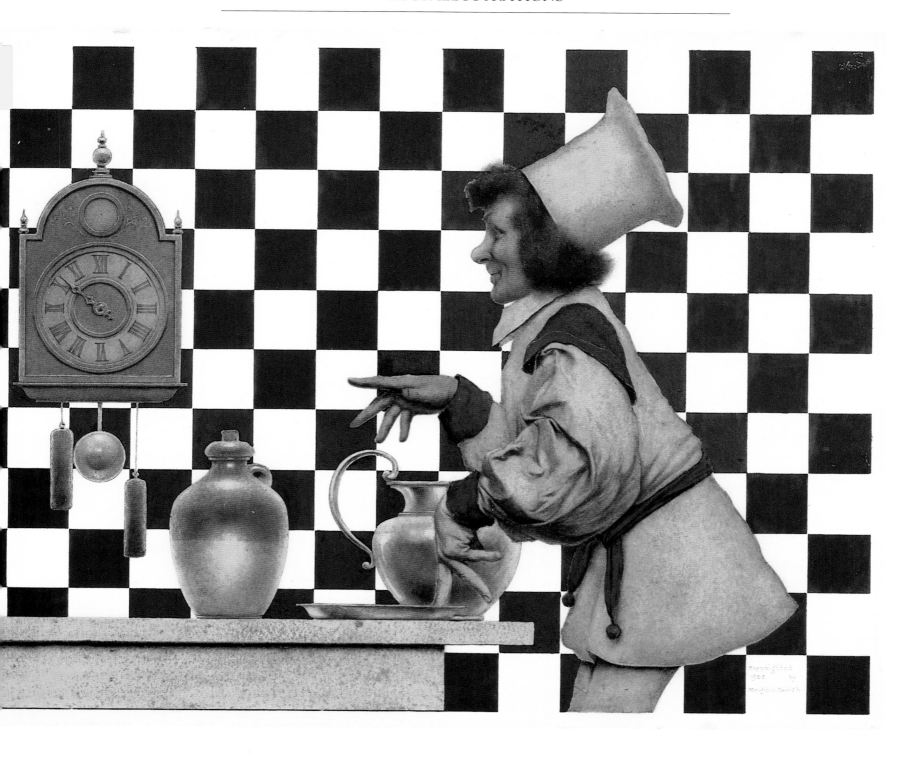

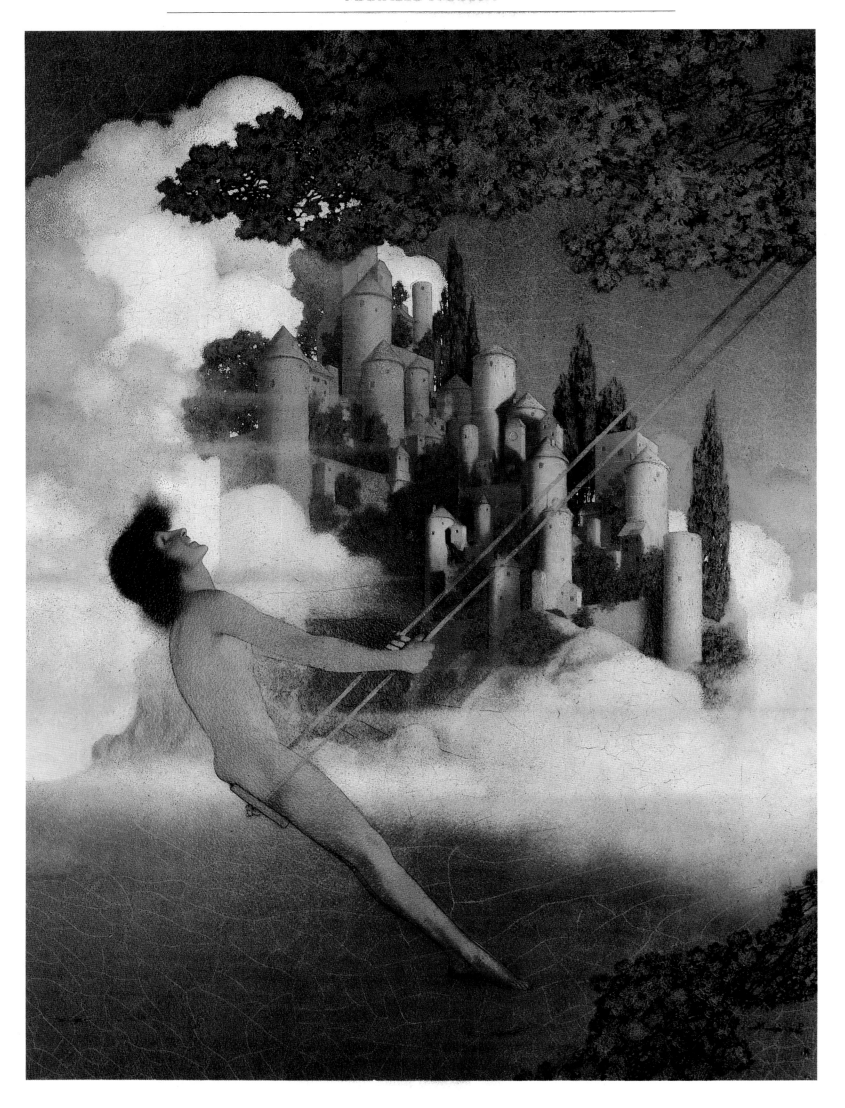

Left:
The Dinkey-Bird, 1904
Poems of Childhood by Eugene Field
Charles Scribner's Sons, 1904
Oil on paper, 21 × 15½ in.
*From the collection of the Charles Hosmer Morse Museum of
American Art, Winter Park, FL*

Fly-Away Horse, 1904
Poems of Childhood by Eugene Field
Charles Scribner's Sons, 1904
Oil on paper on board, 28¼ × 20½ in.
Courtesy: Alan M. Goffman (LUD 374)

The Reservoir, Villa Falconieri, Frascati, 1903
Italian Villas and Their Gardens by Edith Wharton
The Century Company, 1904
Oil on paper, 28 × 18 in.
First appeared in *Century Magazine*, April 1904
Courtesy: The American Illustrators Gallery (LUD 364)

Villa Scassi: Genoa, 1903
Italian Villas and Their Gardens by Edith Wharton
The Century Company, 1904
Oil on paper, 16 × 11 in.
First appeared in *Century Magazine*, October 1904
Courtesy: Jim Seletz (LUD 382)

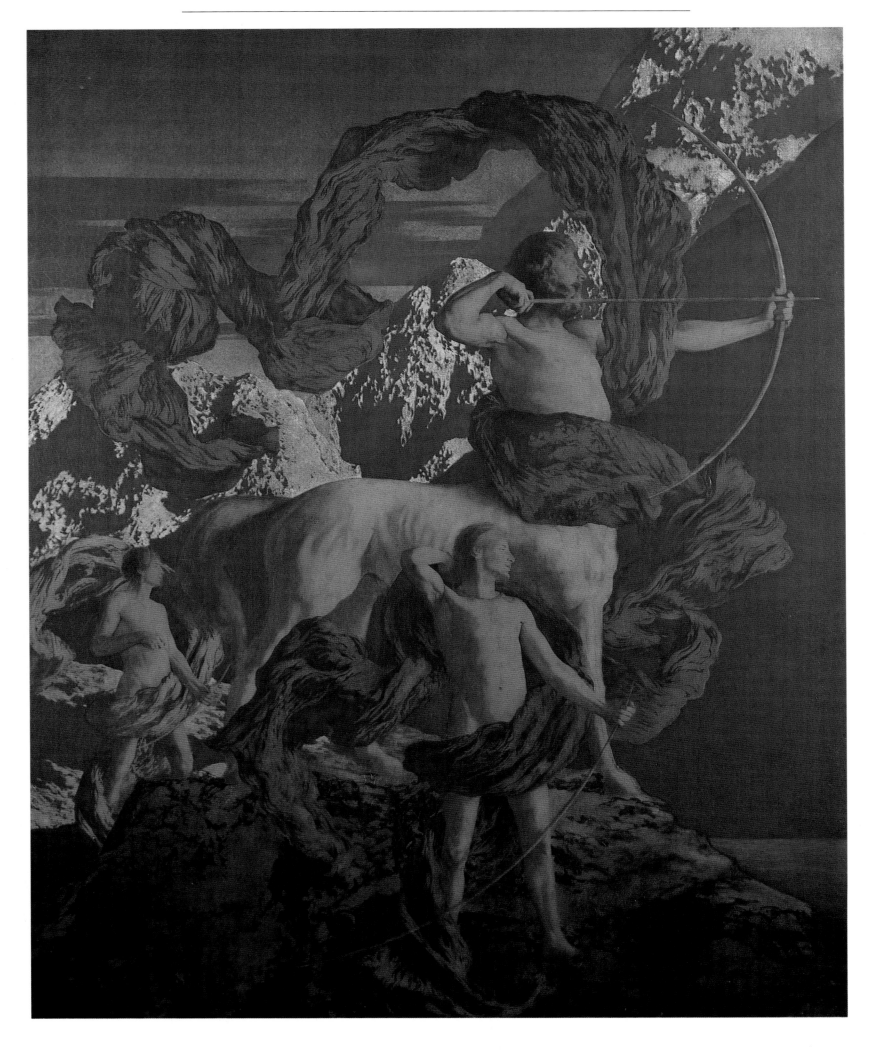

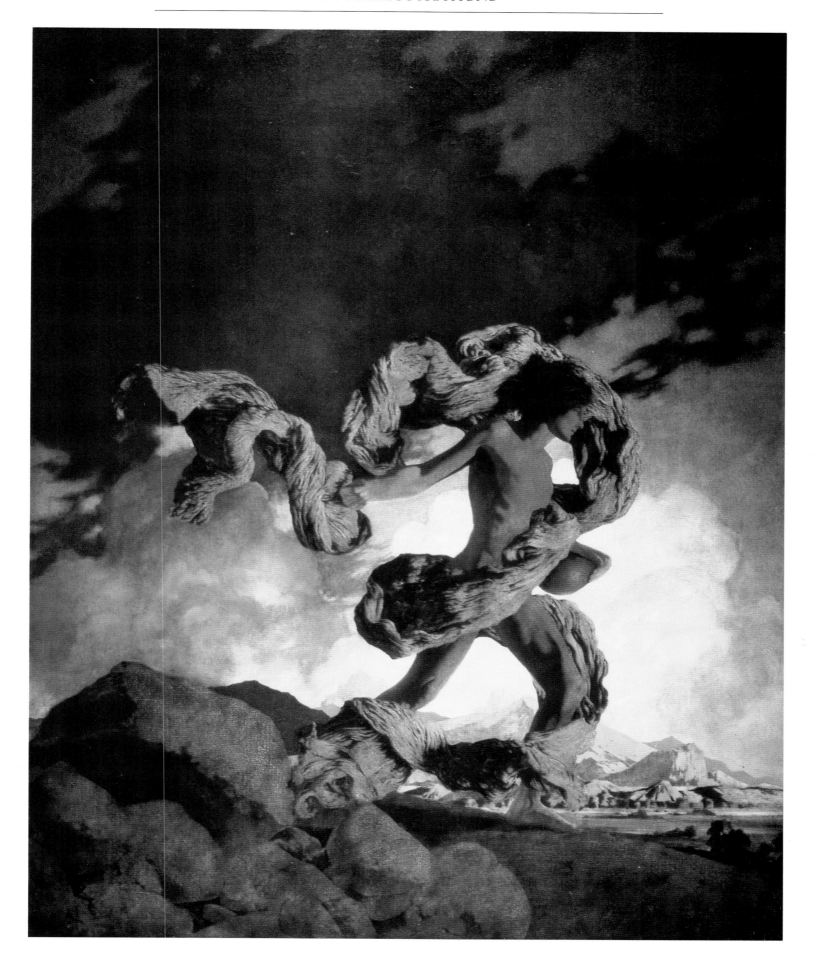

Left:
Jason and His Teacher, 1908
A Wonder Book and Tanglewood Tales by Nathaniel Hawthorne
Duffield and Company, 1910
Oil on canvas on board, 38 × 32 in.
First appeared in *Collier's*, July 23, 1910
Private Collection
Courtesy: The American Illustrators Gallery (LUD 456)

Cadmus Sowing the Dragon's Teeth, 1908
A Wonder Book and Tanglewood Tales by Nathaniel Hawthorne
Duffield and Company, 1910
Oil on canvas on board, 40 × 33 in.
First appeared in *Collier's*, October 31, 1908
Private Collection
Courtesy: The American Illustrators Gallery (LUD 449)

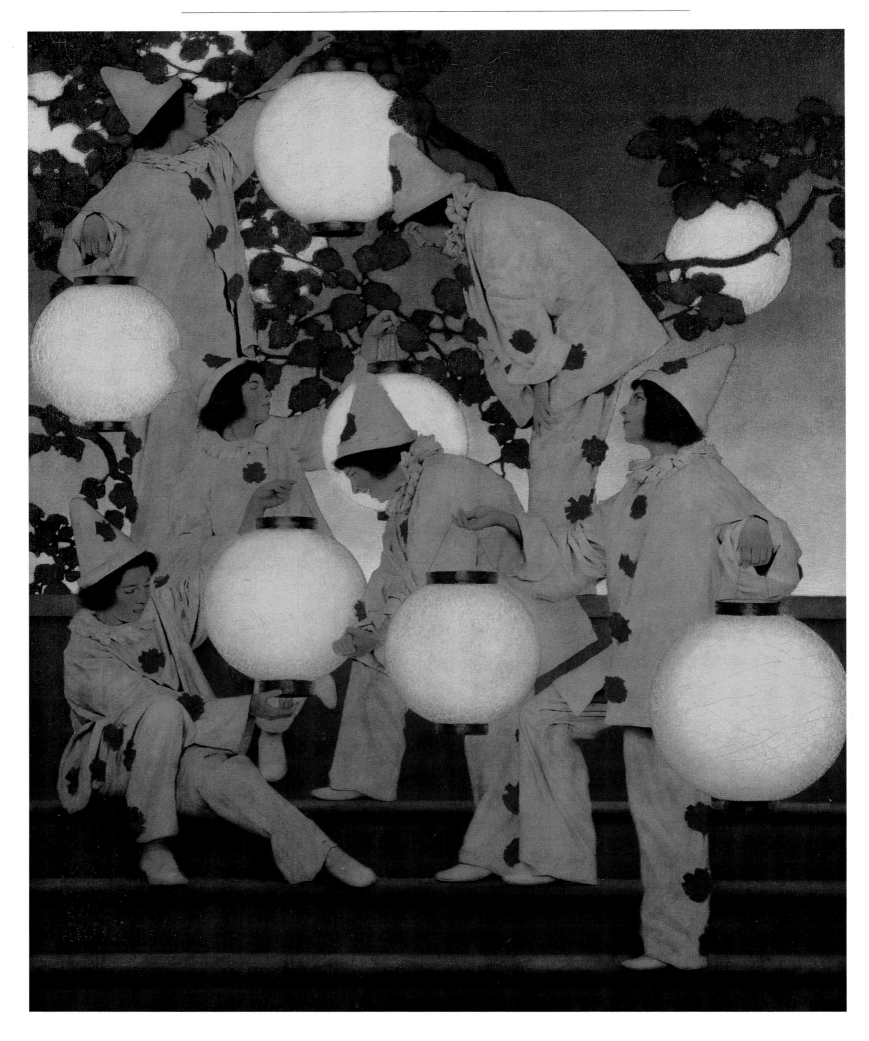

MAGAZINE ILLUSTRATIONS

The study for Parrish's first commissioned work, *Old King Cole*, was directly responsible for launching his career in magazine illustrations. The painting had been shown in New York at the Architectural League and was enthusiastically received. As a result, the editor of *Harper's Bazar* asked Parrish to submit designs for the magazine's 1895 Easter edition cover. When the first cover design was printed, Parrish's work was exposed to a national audience for the first time. For decades thereafter, Parrish's work was constantly before the public.

The period during which Parrish's career flourished is now referred to as "The Golden Age of American Illustration." In the days before radio, cinema and television, publishers had little competition. The more the public read, the more they craved beautiful illustrations to complement their reading. Illustrations sold magazines, and illustrators became celebrities and stars.

In the years following the publication of Parrish's first *Harper's* cover, Parrish designed and illustrated covers for a number of different Harper and Brothers magazines, including *Harper's Round Table*, *Harper's Weekly*, *Harper's Monthly*, and *Harper's Young People*.

Maxfield's father had done etchings for *Century* magazine, the most popular magazine of the time, and in the wake of Maxfield's successes at *Harper's*, Stephen put his son in touch with *Century's* editors. Commissions soon followed steadily, as readership increased exponentially each time one of Maxfield Parrish's works was published.

In 1901, Parrish illustrated "L'Allegro" by John Milton for *Century*, to the delight of the intellectual establishment. Plaudits were received from his friend Augustus Saint-Gaudens, and the artist Celia Beaux raved about his work. Parrish's magazine work had exposed another side of his multi-faceted talent, a side which had been hidden in his earlier, more commercial graphic periodical covers and poster designs. His work had become more delicate, and was elegant enough to enhance poems and short stories for the educated elite.

Century commissioned him to go to Arizona to paint a series of illustrations for an article called "The Great Southwest." This experience in the rugged mountains and canyons so far from New Hampshire imparted a distinctive quality to his work which endured until the end of his career. As a result of that trip, he never treated color and light the same way again. Photography of the rocks and the barren, dry wilderness of the Southwest made their way into many of his subsequent illustrations, no matter what the venue.

Ignited with these publishing successes, Parrish entered and won many competitions and received many awards. Because of these honors, he received even more commissions from such periodicals as *Scribner's*, *Ladies' Home Journal*, *Life*, *Collier's* and *Hearst's*. He painted and drew more covers and illustrated frontispieces, articles, advertisements, short stories, and poems for these and some 25 other national magazines.

In 1903 *Ladies' Home Journal* held a contest for illustrators to do a special cover for their 250th anniversary issue. Parrish won the competition with a painting entitled *Air Castles*. It was so popular that the magazine then issued reprints that were widely distributed. This apparently delighted Parrish, and inspired him to pursue more widespread distribution of his works in the future.

Maxfield Parrish's magazine art was, above all else, unmistakably American. He loved doing it and the public loved seeing it. He described illustrating for periodicals by saying:

> Even making covers for *Life* is mighty good fun. They pay just as well as posters for only the reproduction rights: the originals come back to me, of which I have the exclusive print rights, should any be suitable for that purpose, and I can sell the originals . . . I also want to do some serious painting for publication as prints, for it would be a grand satisfaction to have an income three or four times the price of one poster for a number of years, and own the original as well. This is plain arithmetic, not to mention common business sense. . . .

After all was said and done, Parrish was the "businessman with a brush." Magazines were the perfect outlet for both his talent and his business acumen.

Left:
The Lantern Bearers, 1908
Collier's, December 10, 1910
Oil on canvas, 40 × 32 in.
Private Collection
Courtesy: The American Illustrators Gallery (LUD 485)

April Showers, 1909
Cover, *Collier's*, April 3, 1909
Oil on paper, 22 × 16 in.
Courtesy: Alan M. Goffman (LUD 573)

Right:
Jack and the Giant, 1908
Cover, *Collier's*, July 30, 1910
Oil on paper, 22 × 16 in.
Courtesy: The American Illustrators Gallery (LUD 478)

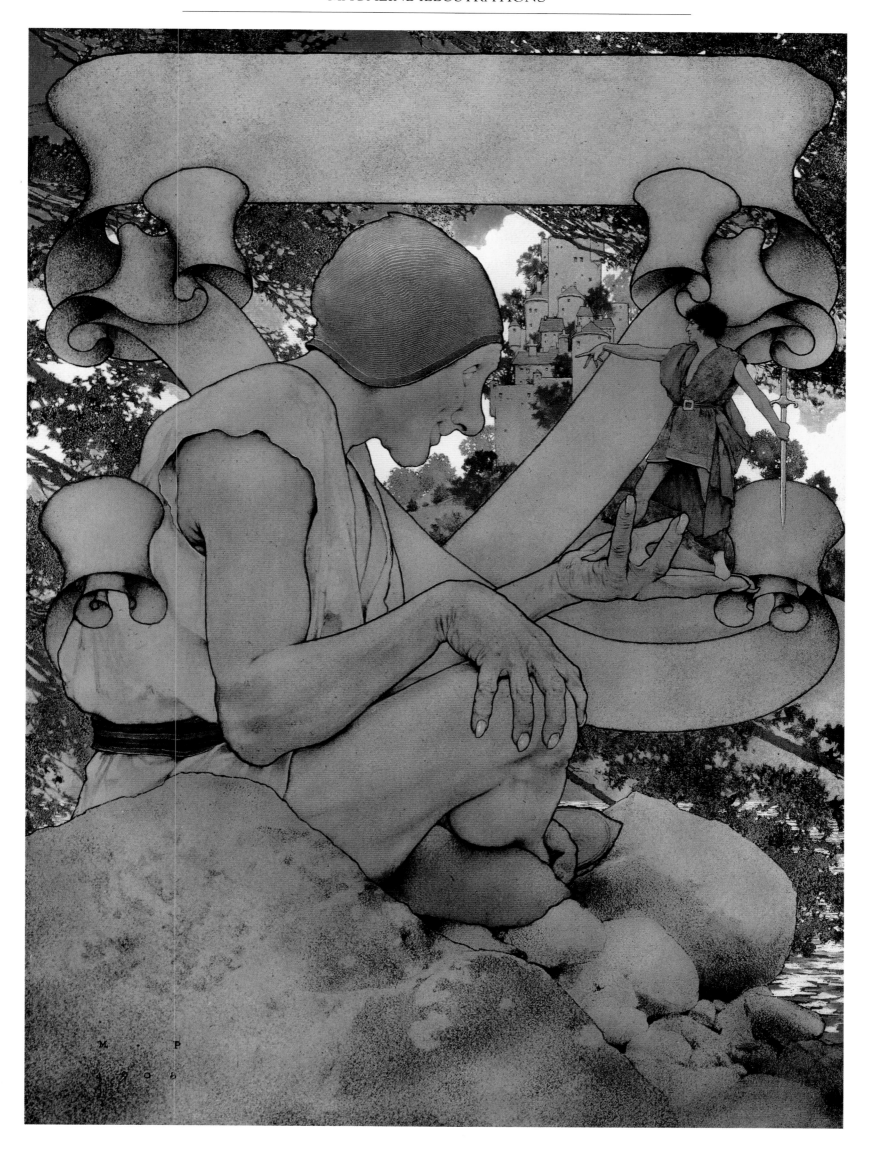

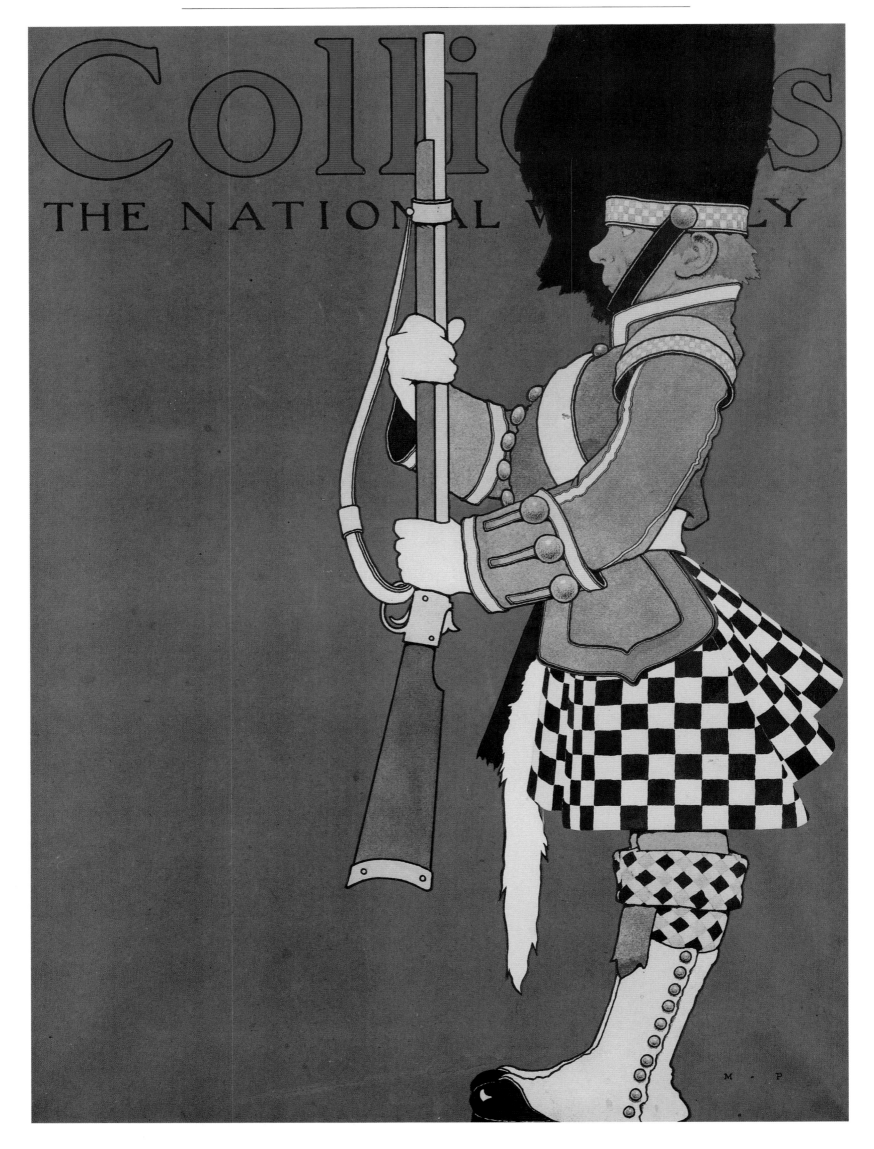

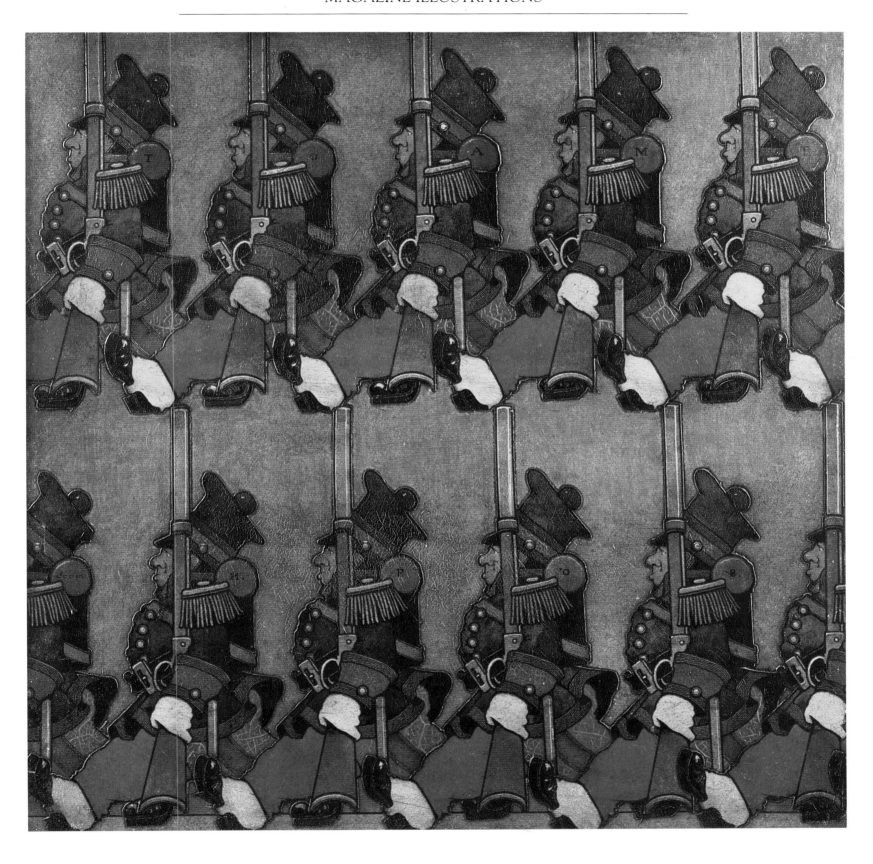

Left:
Comic Scottish Soldier, 1909
Cover, *Collier's*, March 11, 1911
Oil on brown paper, 22 × 16 in.
Courtesy: Jim Seletz (LUD 490)

Parading Soldiers, 1908
Cover, *Collier's*, November 16, 1912
Oil on stretched paper, 16 × 16 in.
Private Collection
Courtesy: The American Illustrators Gallery

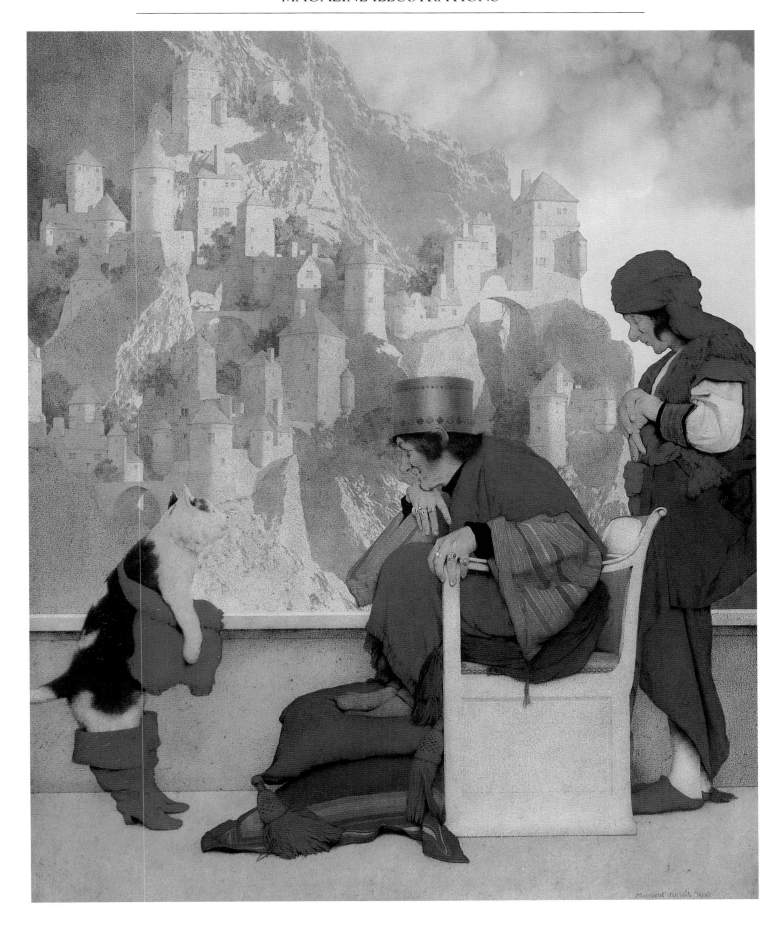

Left:
Sleeping Beauty, 1912
Cover, *Hearst's Magazine*, November 1912
Oil on canvas, 29½ × 24 in.
Courtesy: The American Illustrators Gallery (LUD 598)

Puss in Boots, 1913
Cover, *Hearst's Magazine*, May 1914
Oil on panel, 30 × 24 in.
Courtesy: The American Illustrators Gallery (LUD 599)

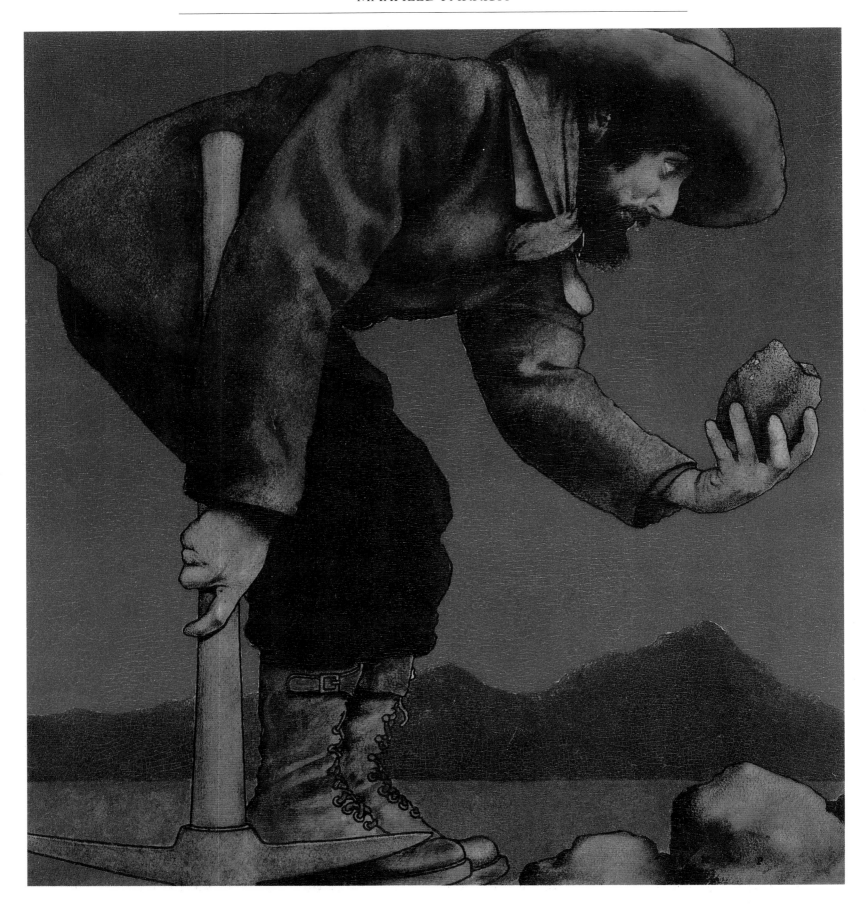

The Prospector, 1909
Cover, *Collier's,* February 4, 1911
Oil on stretched paper, 15½ × 14½ in.
Private Collection
Courtesy: The American Illustrators Gallery (LUD 494)

Right:
Venice-Twilight, 1904
"The Waters of Venice"
by Arthur Symons
Frontispiece, *Scribner's Magazine,* April 1906
Oil on paper, 16 × 14 in.
Courtesy: The American Illustrators Gallery (LUD 390)

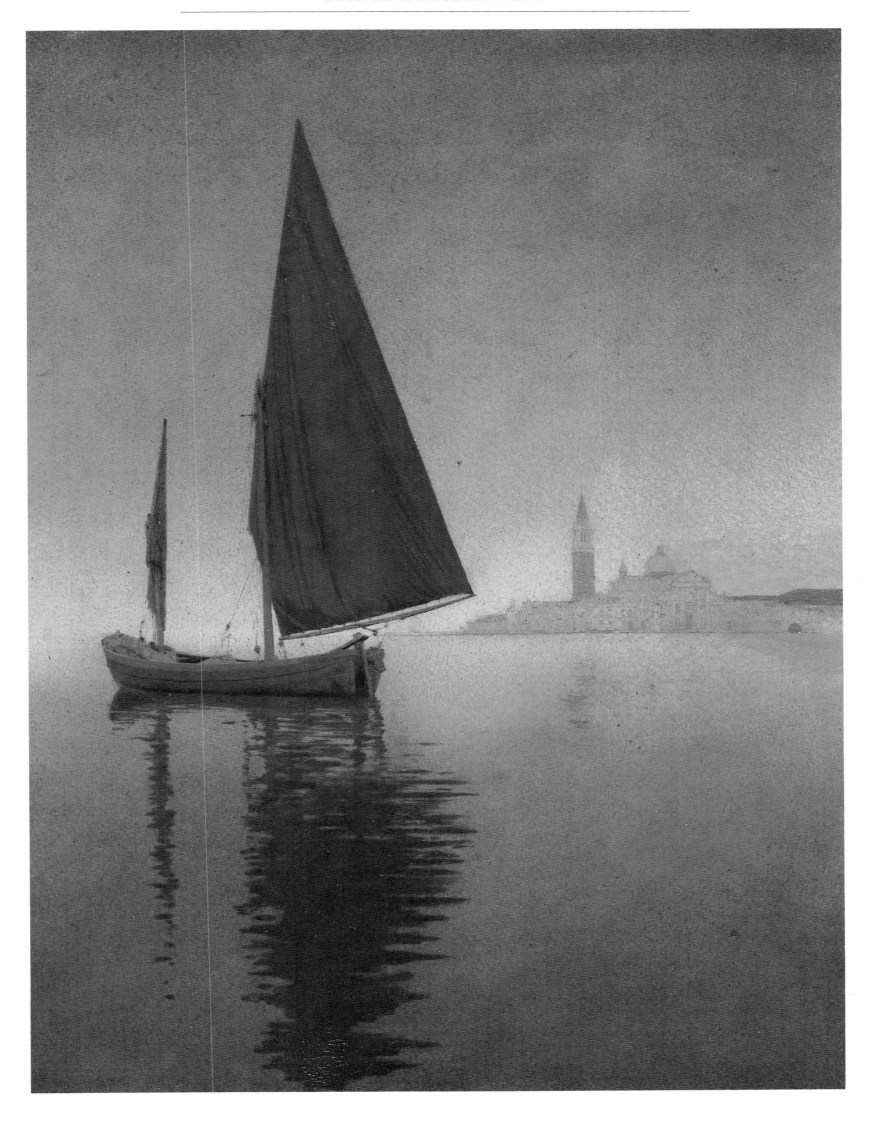

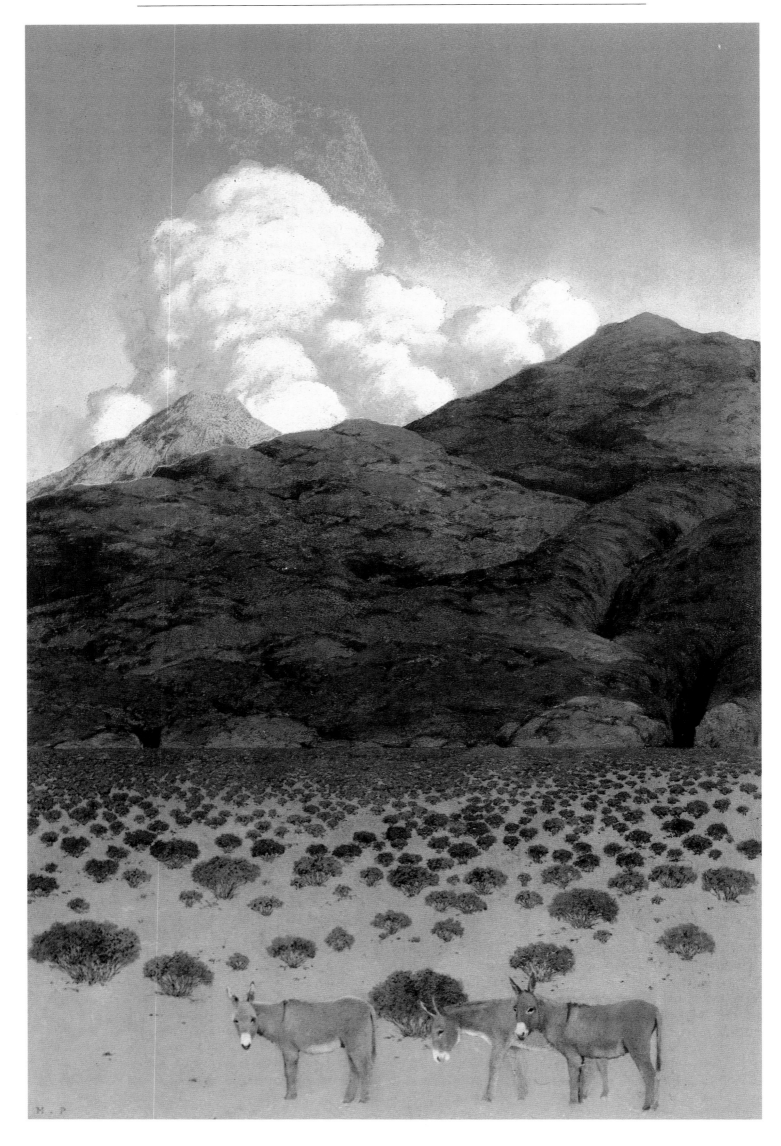

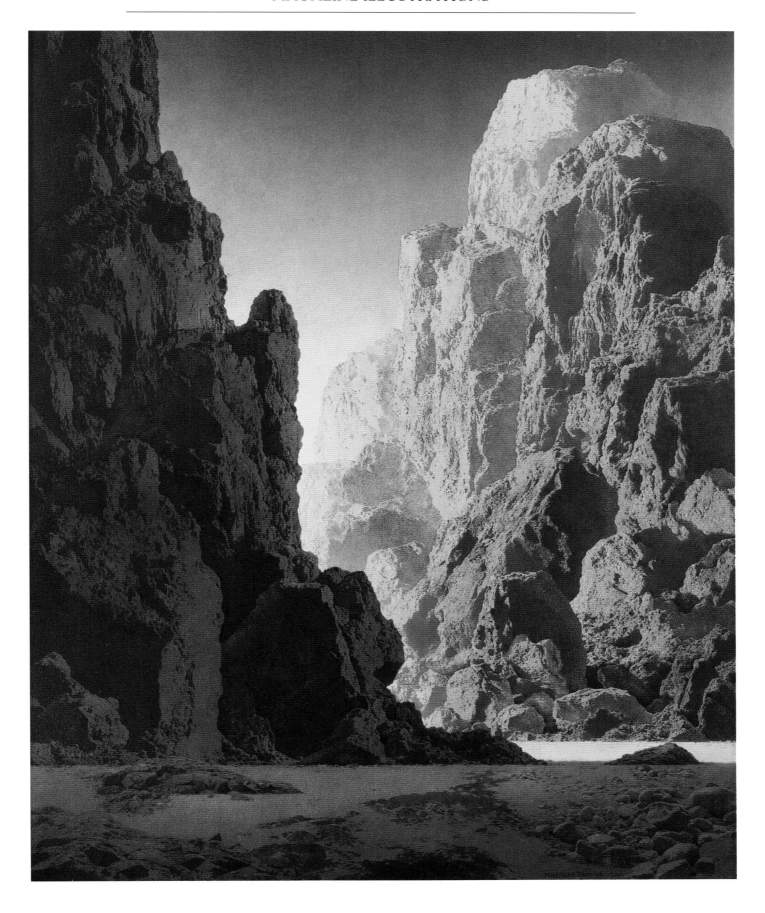

Left:
Formal Growth in the Desert, 1902
"The Great Southwest," Part II, "The Desert"
by Ray Stannard Baker
Century Magazine, November 1902
Oil on board, 17¾ × 11⅞ in.
First appeared in black-and-white
Century Magazine, June 1902
Private Collection
Courtesy: The American Illustrators Gallery (LUD 327)

Arizona [first version], 1930
Frontispiece, *Ladies' Home Journal*, October 1930
Oil on masonite, 30 × 25 in.
Courtesy: The American Illustrators Gallery (LUD 739)

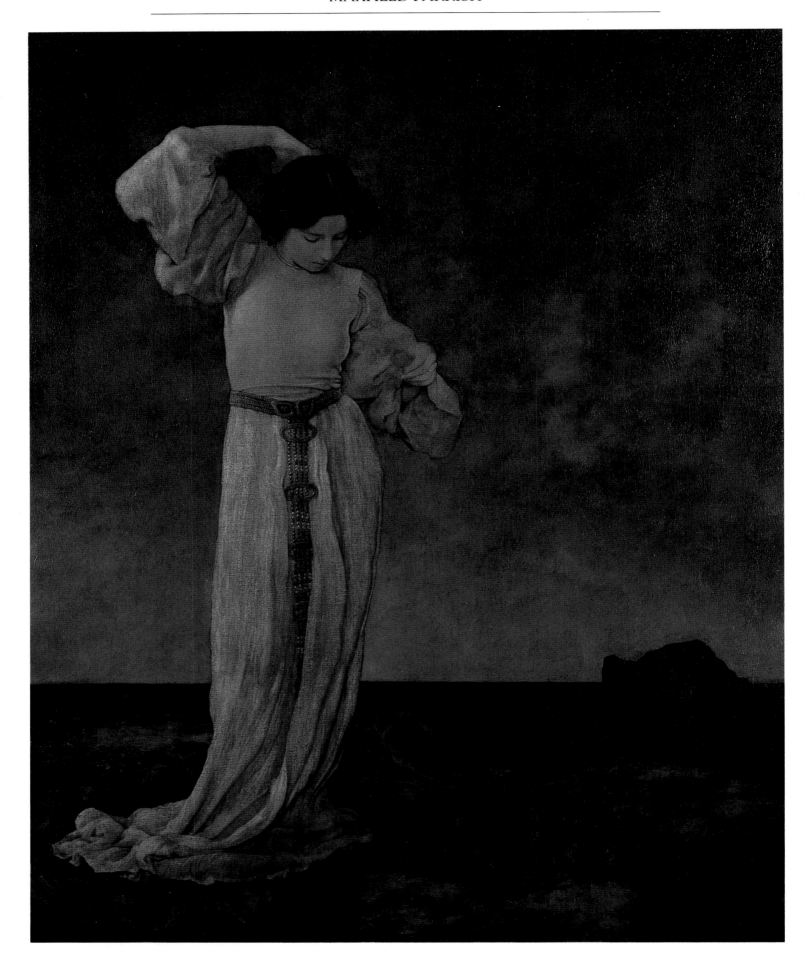

Seven Green Pools at Cintra, 1910
"Seven Green Pools at Cintra" by Florence Wilkinson
Frontispiece, *Century Magazine*, August 1910
Oil on board, 39 × 31½ in.
(Background later painted out and painting re-titled
Griselda)
Private Collection
Courtesy: The American Illustrators Gallery (LUD 518)

Right:
Egypt, 1902
"The Three Caskets" by George M. R. Twose
St. Nicholas, December 1903
Oil on paper, 15 × 12 in.
Courtesy: The American Illustrators Gallery (LUD 337)

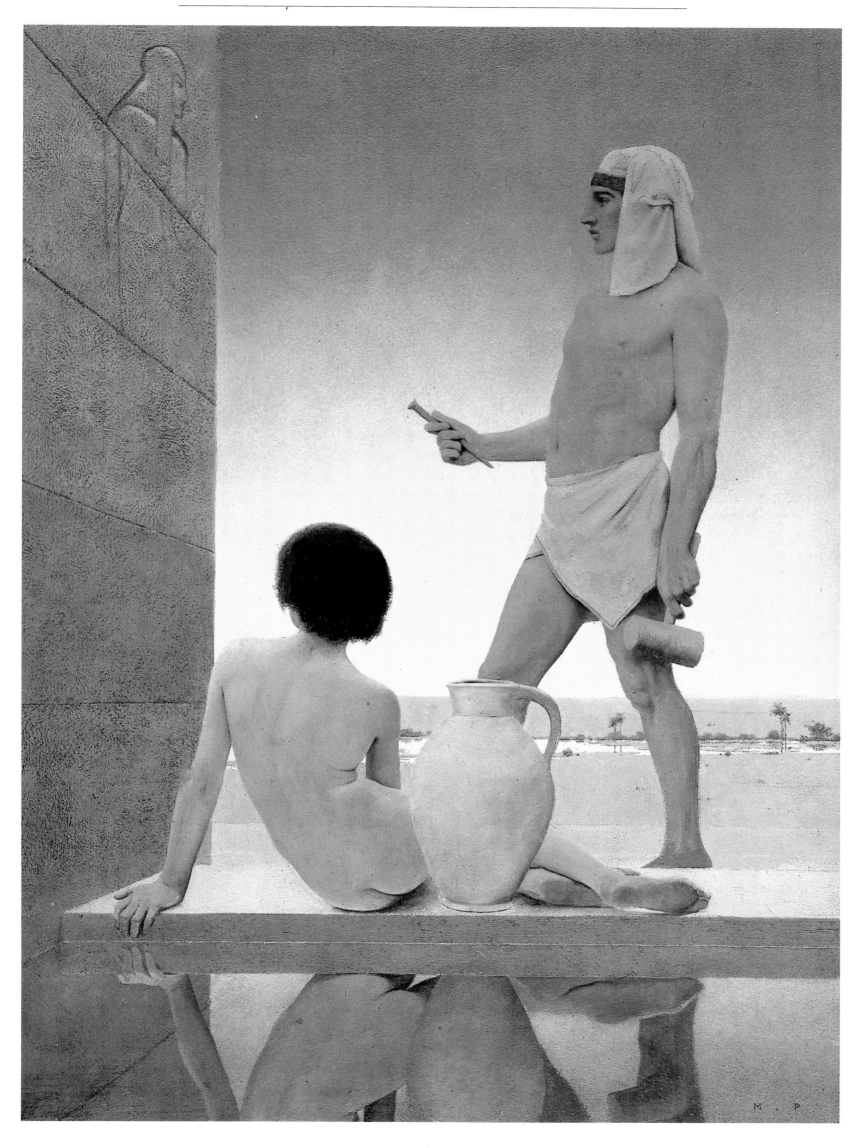

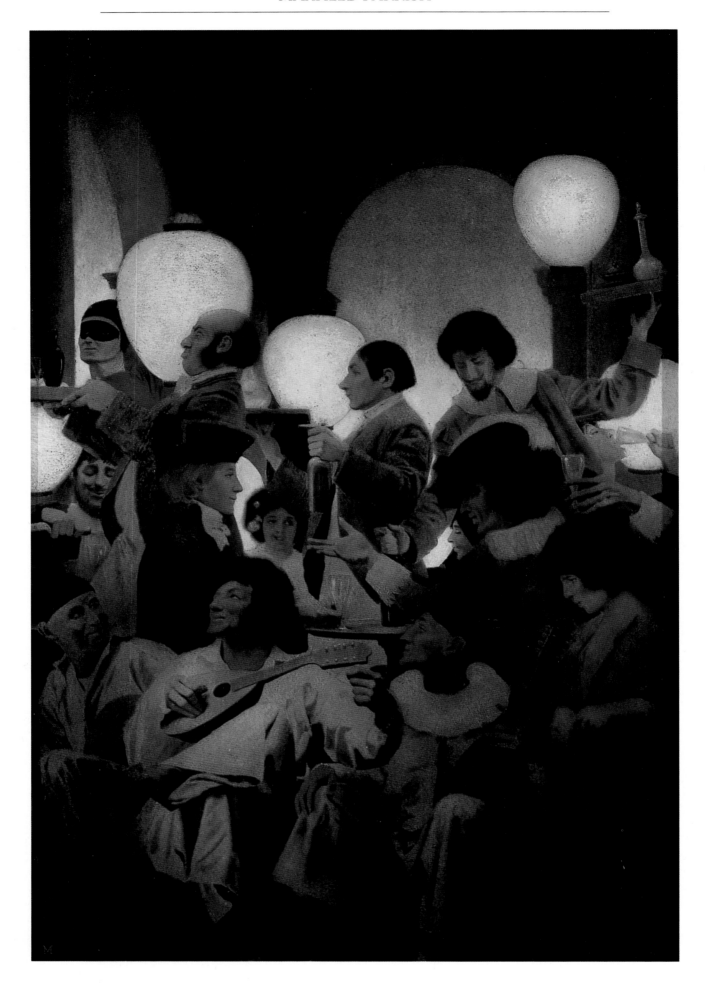

A Venetian Night's Entertainment, 1903
"A Venetian Night's Entertainment" by Edith Wharton
Frontispiece, *Scribner's Magazine*, December 1903
Oil on paper, 17¼ × 11¾ in.
Courtesy: The American Illustrators Gallery (LUD 351)

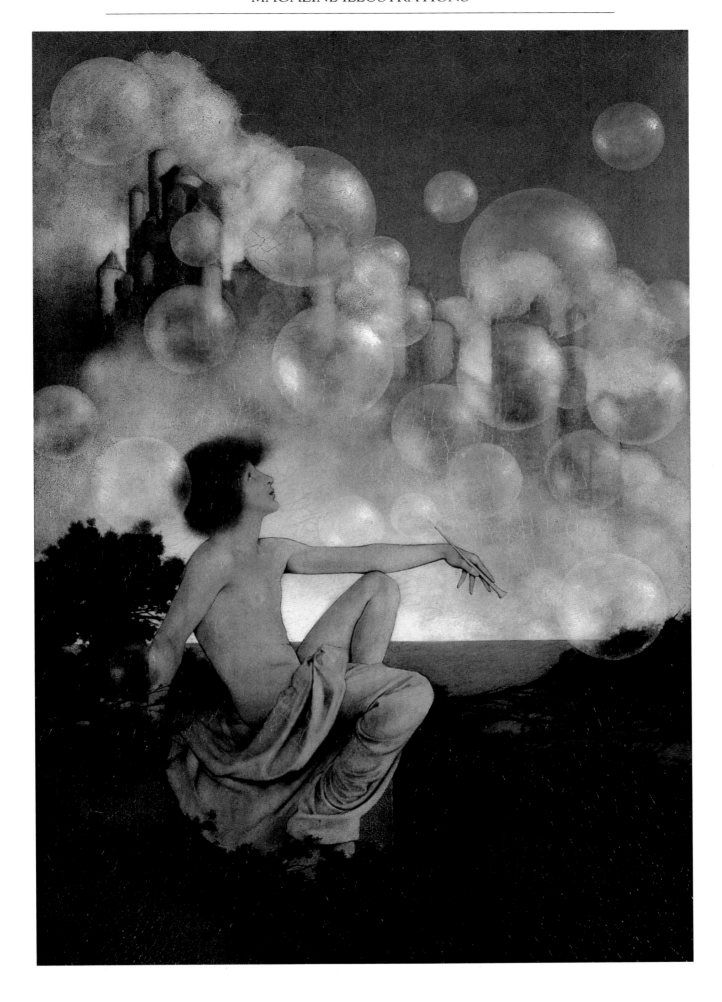

Air Castles, 1904
Cover, *Ladies' Home Journal*, September 1904
Oil on board, 29 × 20 in.
Private Collection
Courtesy: The American Illustrators Gallery (LUD 557)

Study for Daybreak, 1922
Watercolor and collage, 15 × 24 in.
Courtesy: The American Illustrators Gallery (LUD 681)

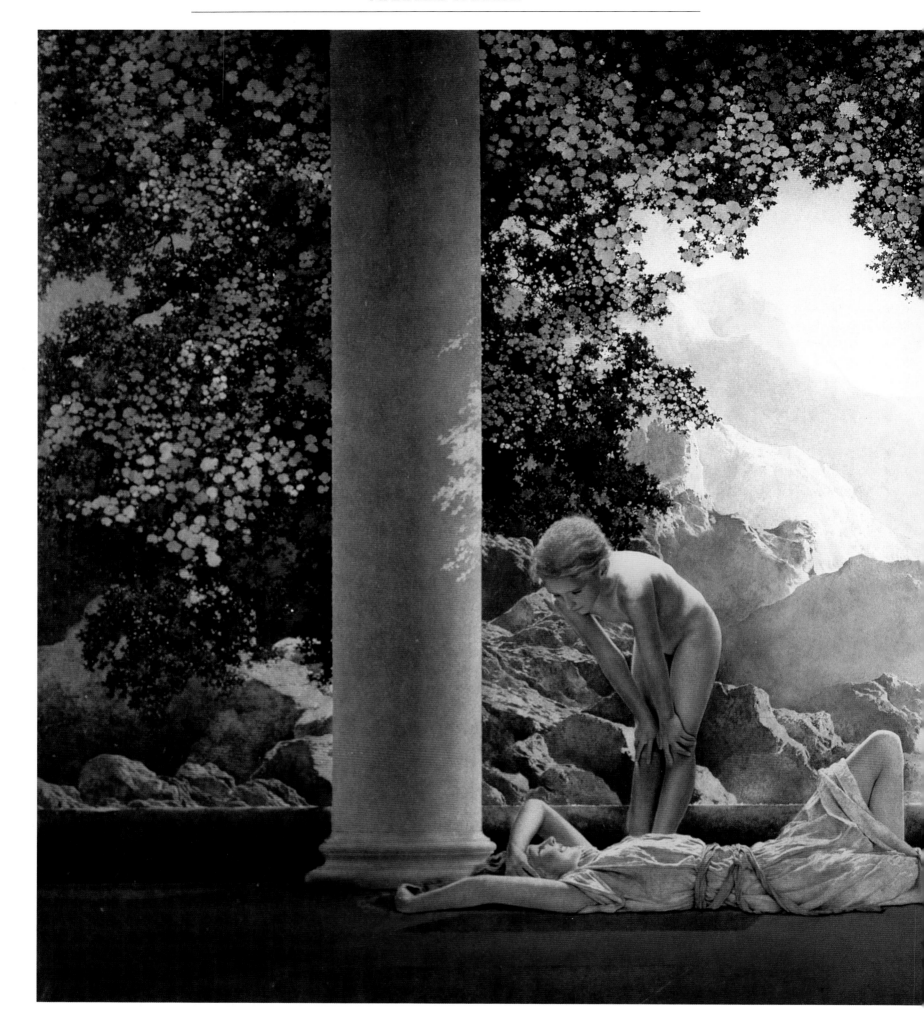

Daybreak, 1922
Oil on panel, 26 × 45 in.
Issued late summer or early fall 1923, The House of Art
Print sizes: 6 × 10 in., 10 × 18 in., 18 × 30 in.
Private Collection
Courtesy: The American Illustrators Gallery (LUD 682)

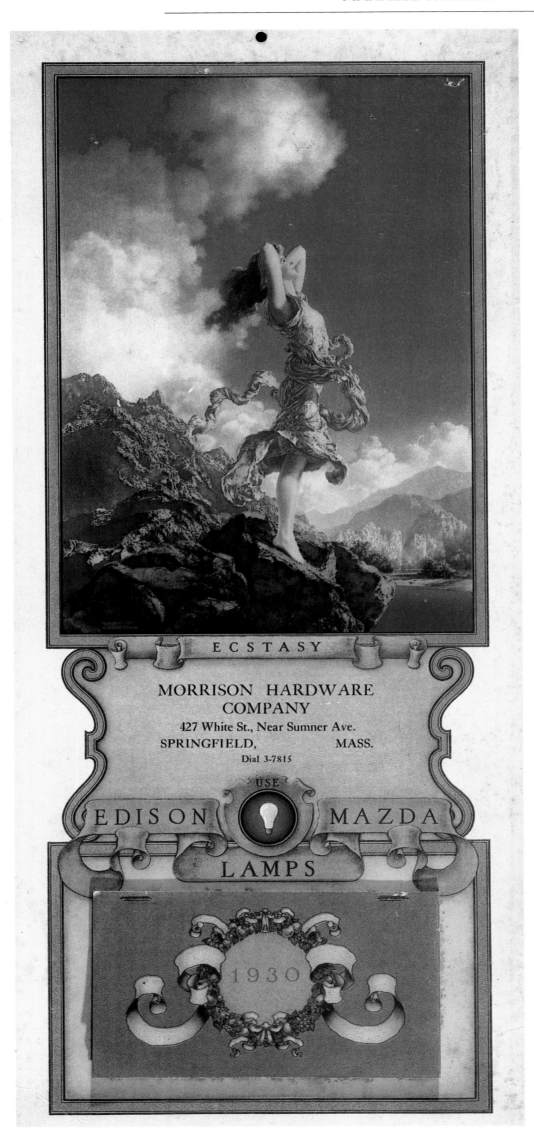

ECSTASY

MORRISON HARDWARE
COMPANY
427 White St., Near Sumner Ave.
SPRINGFIELD, MASS.
Dial 3-7815

USE
EDISON MAZDA
LAMPS

1930

Left:
Ecstasy, 1929
Oil on panel, 36 × 24 in.
General Electric Mazda Lamps Calendar, 1930
Private Collection
Courtesy: The American Illustrators Gallery
(LUD 728)

Right:
Venetian Lamplighter, 1922
Oil on panel, 28¾ × 18¾ in.
General Electric Mazda Lamps Calendar, 1924
Courtesy: The American Illustrators Gallery
(LUD 683)

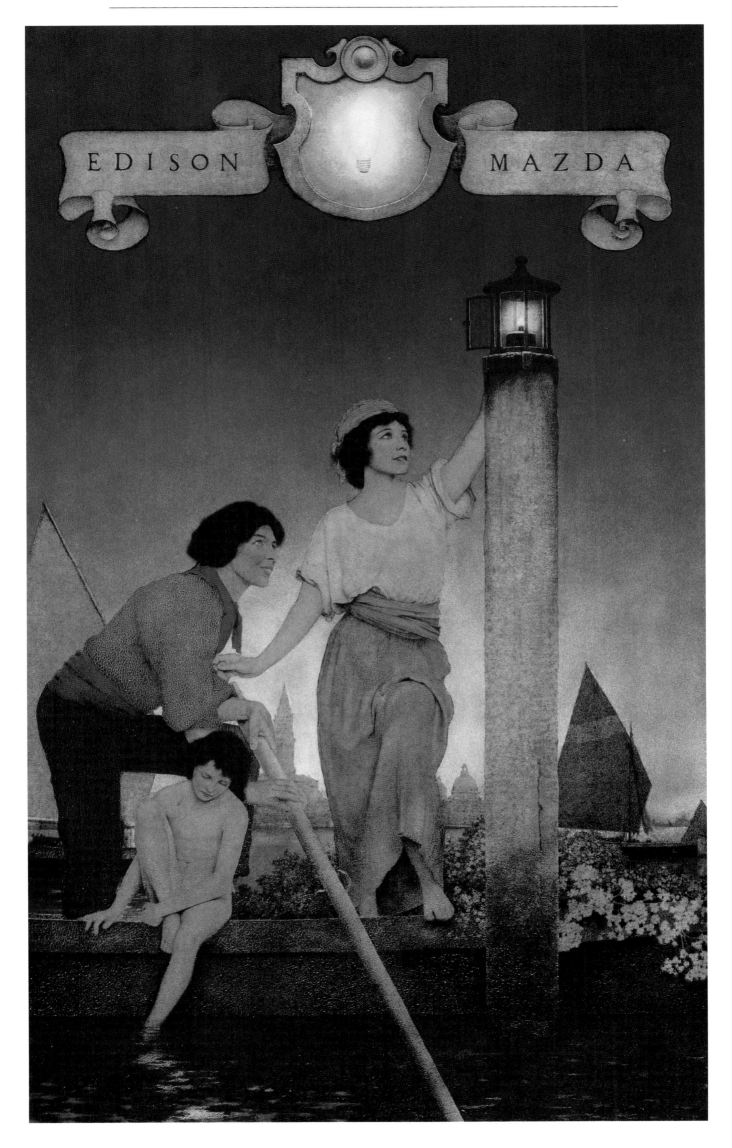

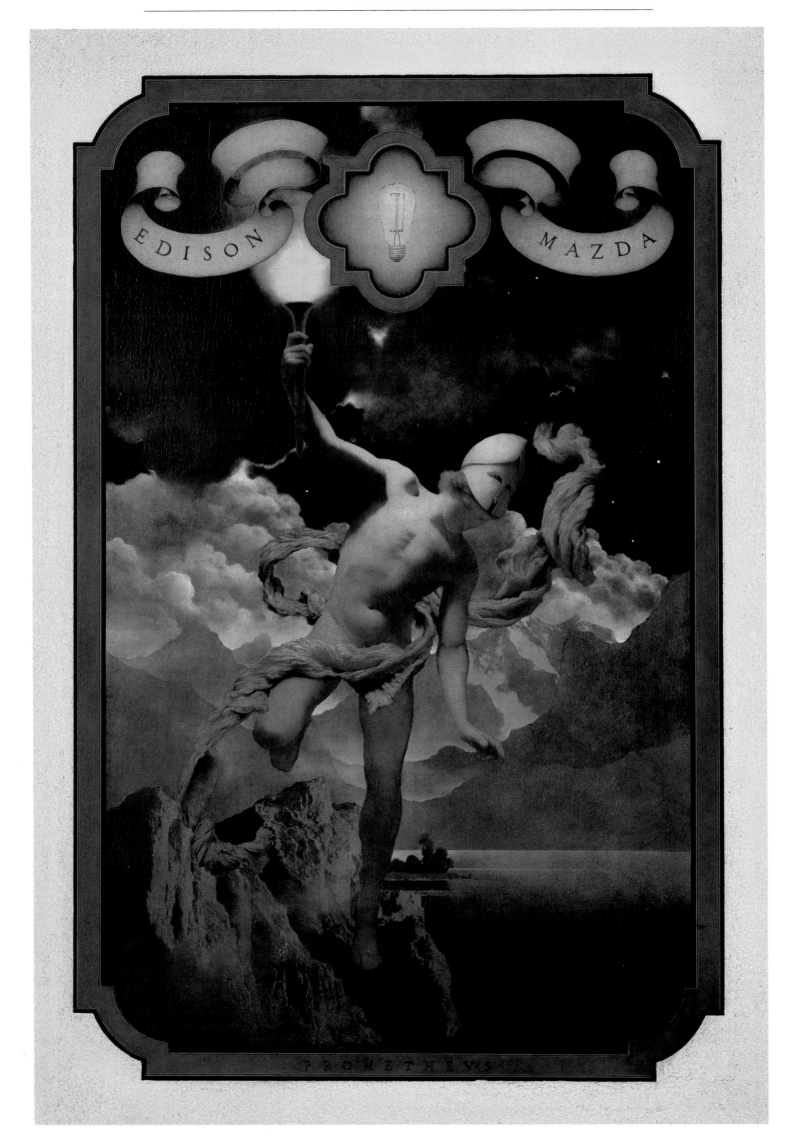

Left:
Prometheus, 1919
Oil on panel, 28 × 18 in.
General Electric Mazda Lamps Calendar, 1920
Private Collection
Courtesy: The American Illustrators Gallery
(LUD 651)

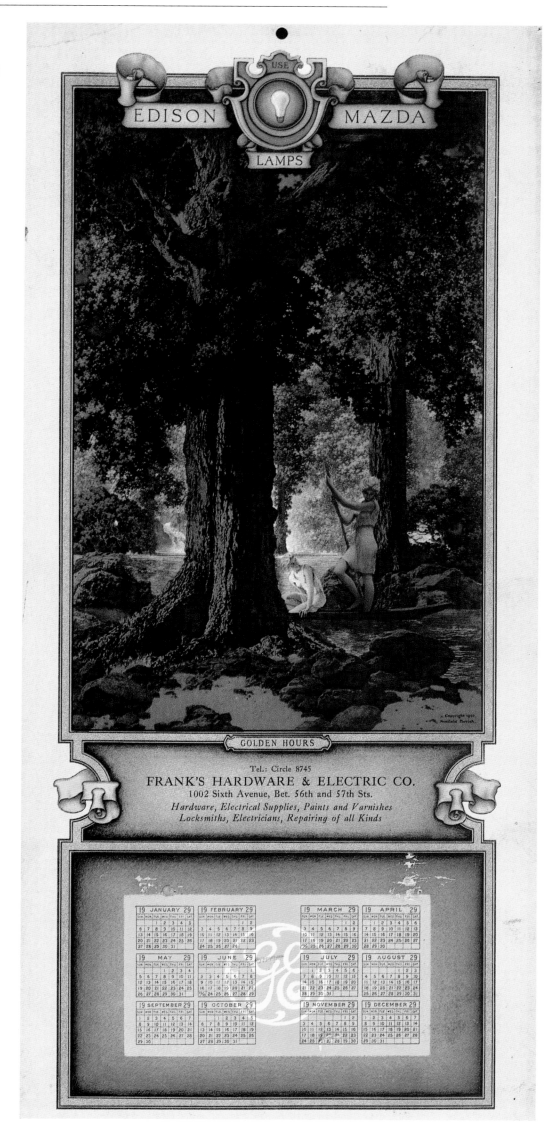

Right:
Golden Hours (Autumn), 1927
Oil on panel, 30 × 17 in.
General Electric Mazda Lamps Calendar, 1929
Courtesy: The American Illustrators Gallery
(LUD 726)

Left:
Sunrise, 1931
Oil on panel, 31¾ × 22½ in.
General Electric Mazda Lamps Calendar, 1933
Private Collection
Courtesy: The American Illustrators Gallery (LUD 742)

Reverie, 1926
Oil on panel, 35 × 22 in.
General Electric Mazda Lamps Calendar, 1927
Courtesy: The American Illustrators Gallery (LUD 723)

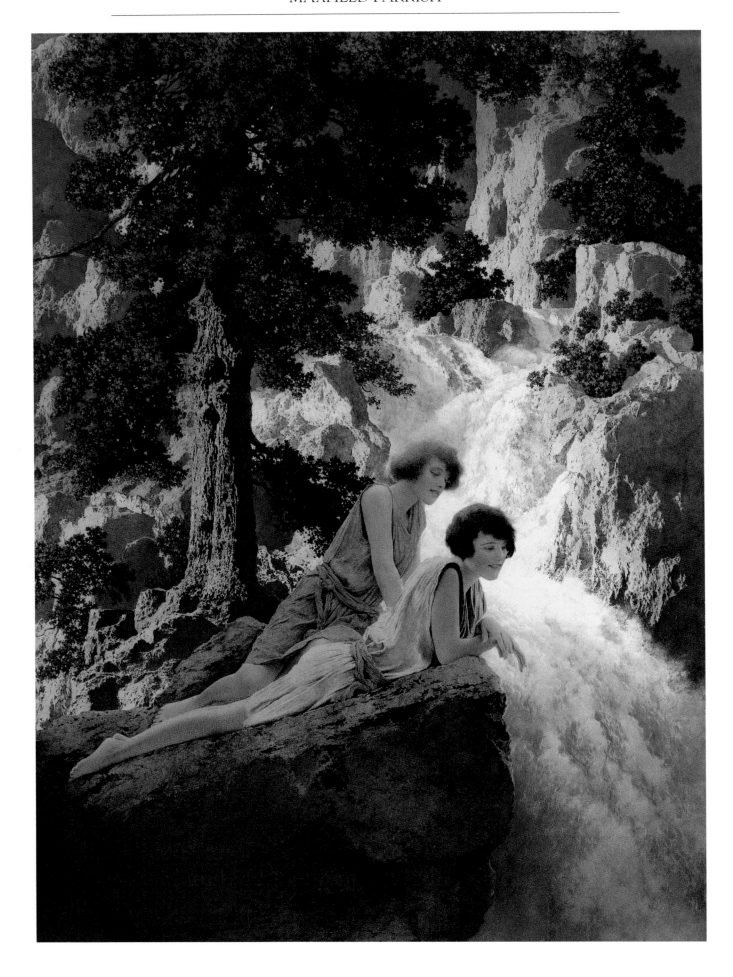

Waterfall, 1930
Oil on panel, 32 × 22 in.
General Electric Mazda Lamps Calendar, 1931
Private Collection
Courtesy: The American Illustrators Gallery (LUD 735)

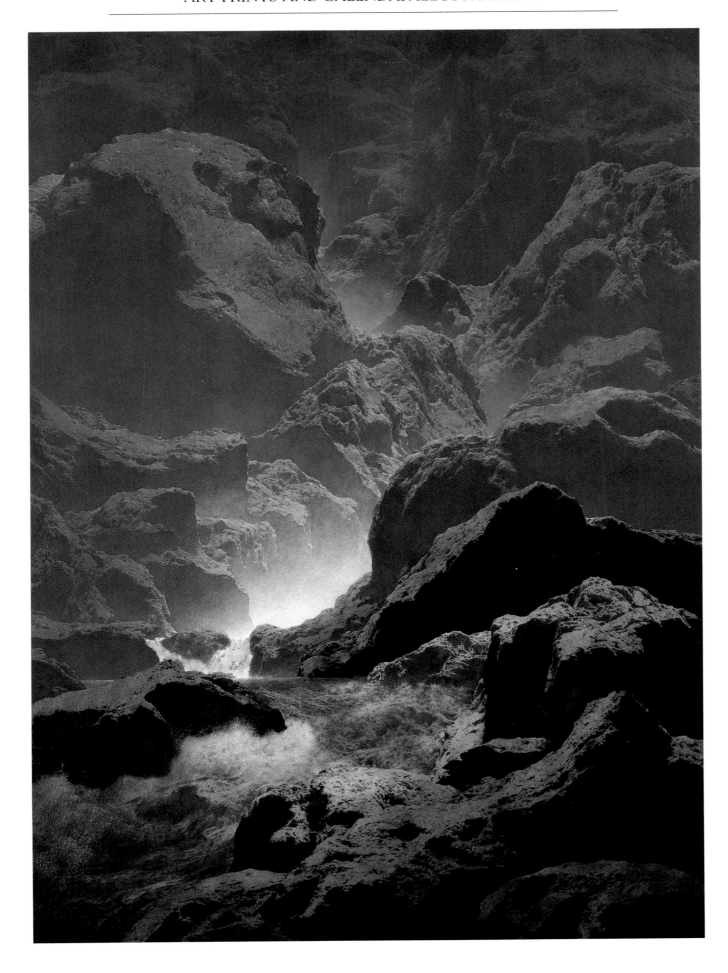

Moonlight, 1932
Oil on panel, 32⅝ × 22¾ in.
General Electric Mazda Lamps Calendar, 1934
Private Collection (LUD 744)

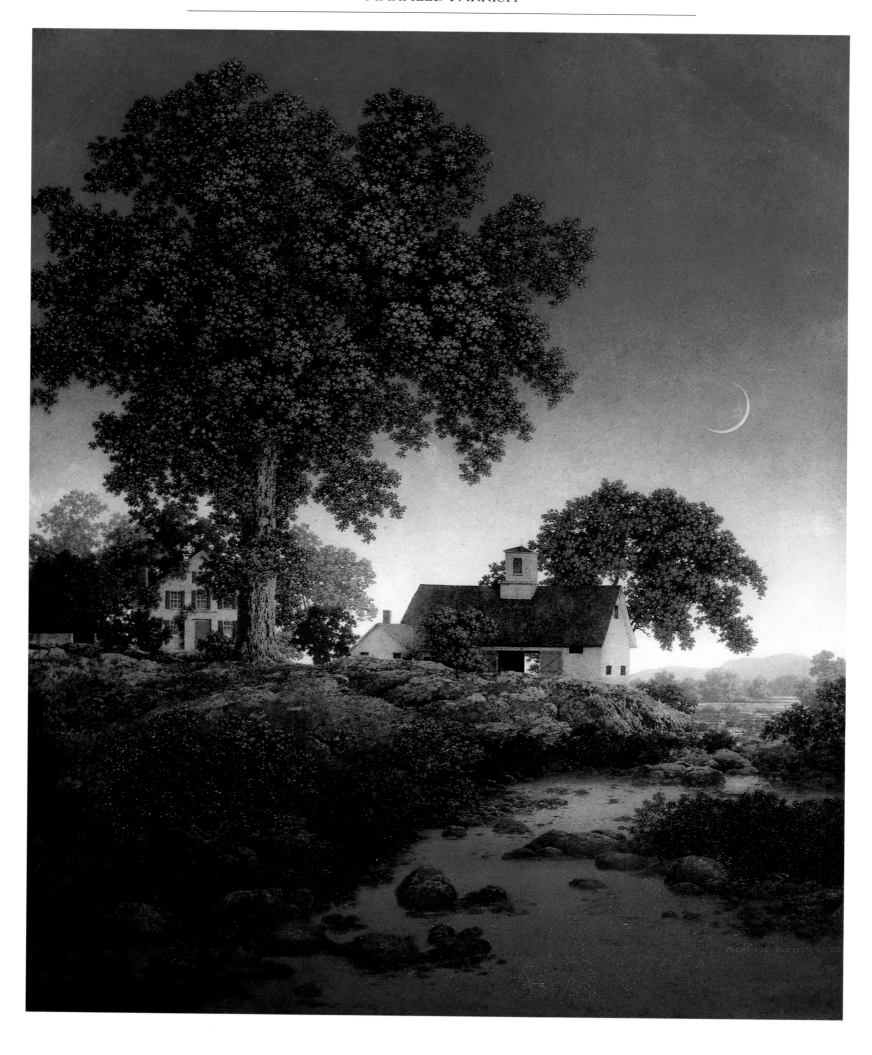

LANDSCAPES

As he entered his 60s, Parrish turned to painting his favorite subject – landscapes. Although he seemed to enjoy the technical execution of everything he ever created, the bother of dealing with businessmen and the correspondence required to keep them happy had become too much of an effort. He had also tired of the subject of light in his Edison Mazda work, especially as it expressed itself in a never-ending demand for more paintings of "girls on rocks." He simply wanted to paint peaceful landscapes and sell them to collectors or license them for use as calendars to continue a steady flow of income.

By 1931 Parrish had turned exclusively to easel art and straight landscape painting. Barns, trees, meadows, mountains and ponds were all Parrish ever painted again. These paintings never reached the popularity of his "girl on a rock" theme, nor did they come close in popularity to his best-selling magnum opus, *Daybreak*; nevertheless, they were sublimely executed and much coveted.

In the years during which he produced illustrations for the Edison Mazda calendars, he increasingly employed detailed landscapes in the background. Ultimately he reworked some of these paintings into landscapes by removing the figures altogether; *Moonlight* is such an example. In these cases he gave the work a new title and even resold the reproduction rights to a new client, for a new audience, years after the original work had been executed.

Always fond of landscapes, he had always attempted to include a landscape in his work, no matter what the assignment, later altering it into an imaginary landscape if an opportunity warranted such effort. When asked about "realism" in his landscapes he said, "My theory is that you should use all objects in nature, trees, hills, skies, rivers and all, just as stage properties . . . on which to hang your idea . . . you cannot sit down and paint such things; they are not there or do not last but for a moment. 'Realism' of impression, the mood of the moment, yes, but not the realism of things. The colored photograph can do that better."

In 1935 he signed a contract with Brown and Bigelow Publishing Company of St. Paul, Minnesota, to produce landscape illustrations for calendars. At an age when most retire, Parrish embarked on another direction in his career by entering into this agreement. The next year, Brown and Bigelow said that the calendar with his *Elm, Late Afternoon* was the first time a landscape theme was the most popular of their entire range of calendars, and this pleased him very much. Yet when Brown and Bigelow once suggested that he put more excitement into a farm scene, Parrish became annoyed at being instructed by his client about what to paint. He replied that the only way "to make it more exciting would be to set the barn on fire."

His landscapes became annual exercises of saturated color and exquisitely articulated detail – Parrish's true forte. They were constructed from photographs used in composite by juxtaposing images from his travels with those from his familiar New England surroundings. To a large extent, the landscapes included the great oak trees from his estate in Cornish. When studying his glass slide collection one readily notices that the same images and the same trees or chards of these 4 × 5 inch plates were used repeatedly. These images were sometimes reversed, sometimes placed at a distance in a valley, and other times placed in the foreground, at a different scale. In his idealized views of make-believe places, the colors draw the viewer's eyes from rich autumn oranges to contrasting aquamarine skies. The paintings are uniformly luminescent, due to the layering of pure colors, straight from the tubes of paint, employed on a white ground. His preference for framing these fantasy landscapes was a dull gilt, "else they would blind the observer so he couldn't see the picture."

Left:
New Moon, 1958
Oil on panel, 23 × 19 in.
Brown and Bigelow Calendar, 1958
Private Collection
Courtesy: The American Illustrators Gallery (LUD 838)

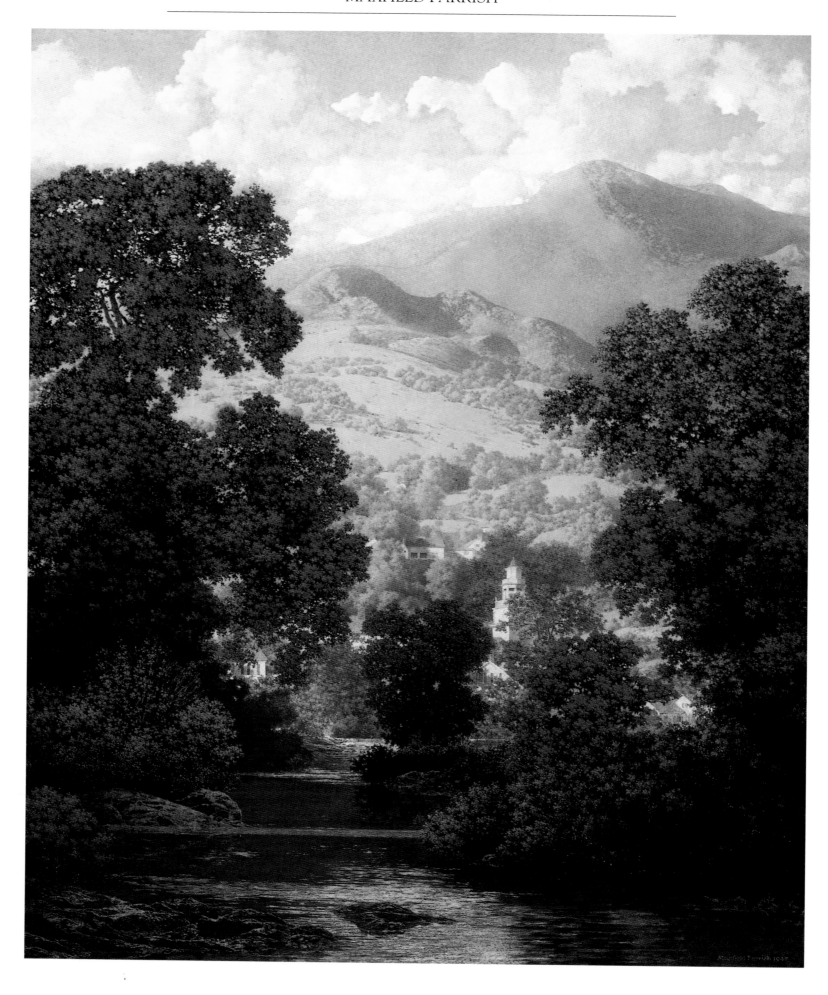

Sunlit Valley, 1947
Oil on panel, 23 × 19 in.
Brown and Bigelow Calendar, 1950
Private Collection
Courtesy: The American Illustrators Gallery (LUD 803)

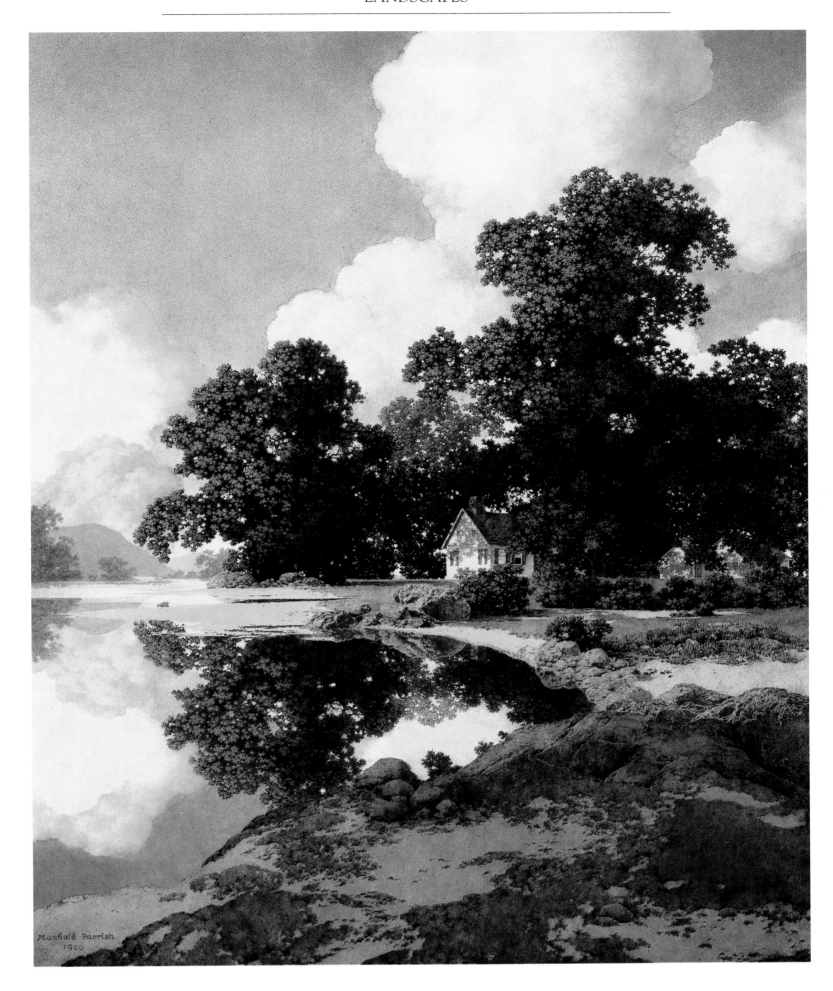

Sheltering Oaks (A Nice Place to Be), 1956
Oil on board, 23 × 18½ in.
Brown and Bigelow Calendar, 1960
Private Collection
Courtesy: The American Illustrators Gallery (LUD 841)

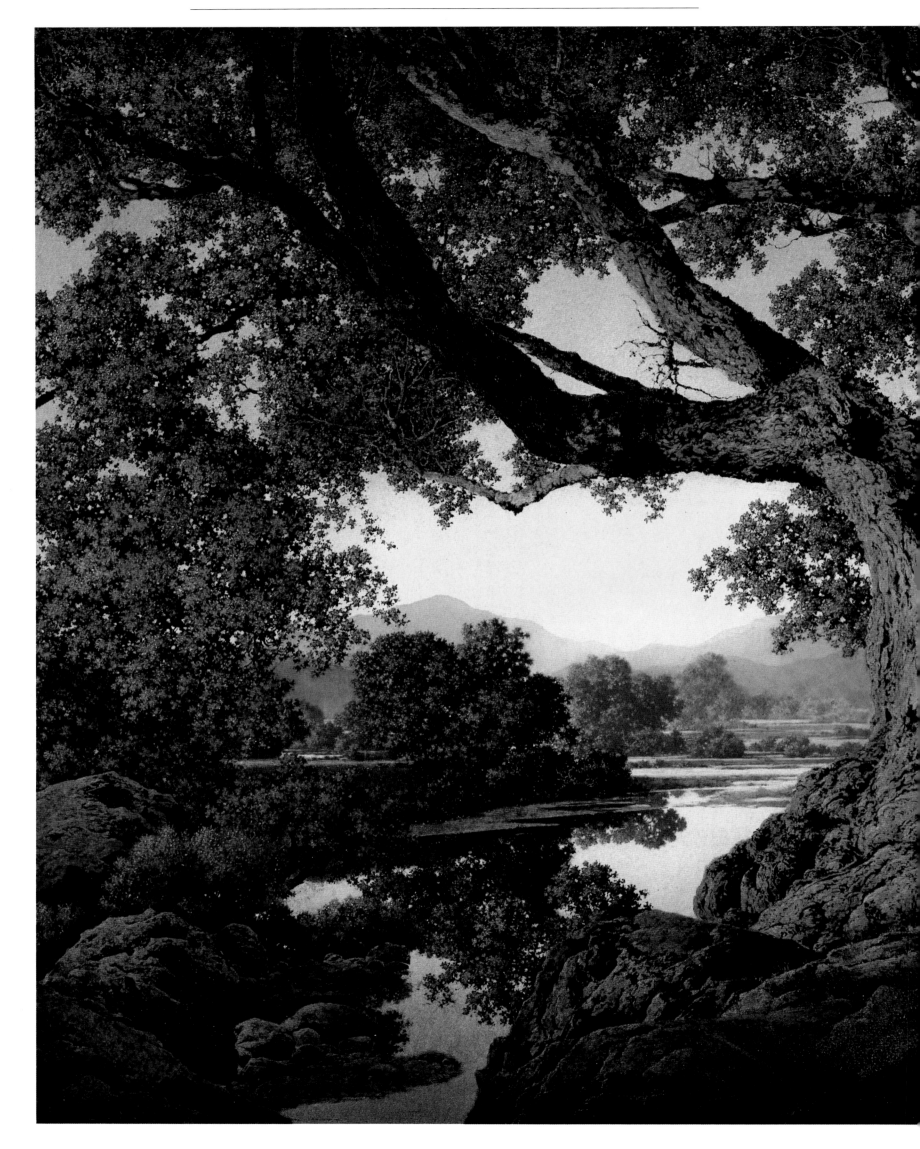

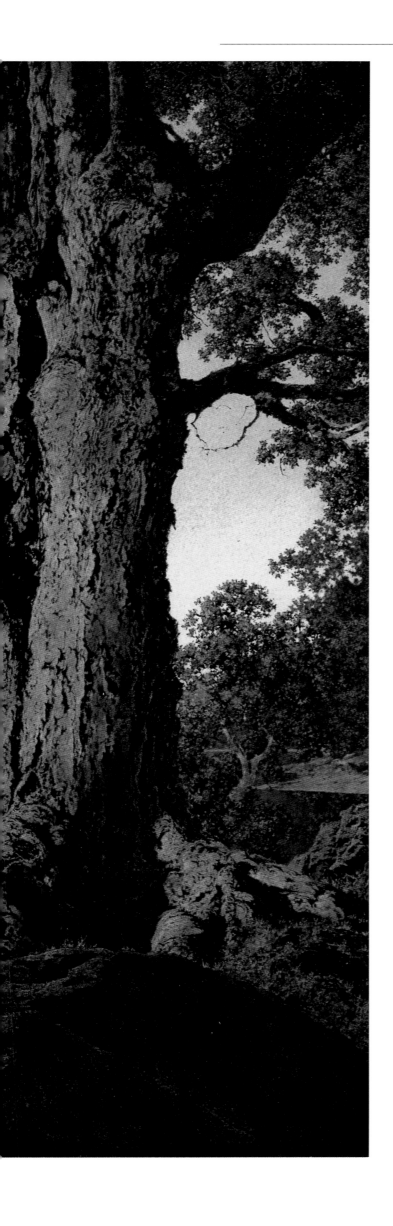

Riverbank, Autumn, 1938
Oil on board, 17½ × 20 in.
Courtesy: Riekes International LP

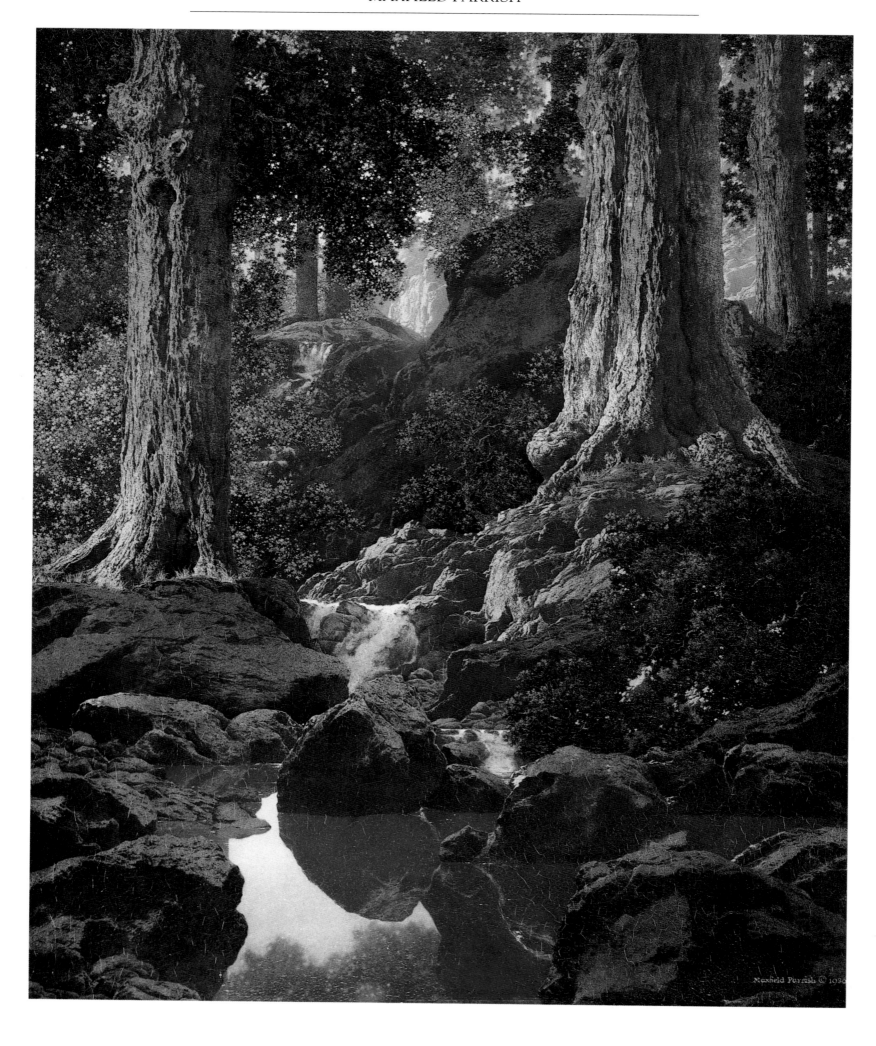

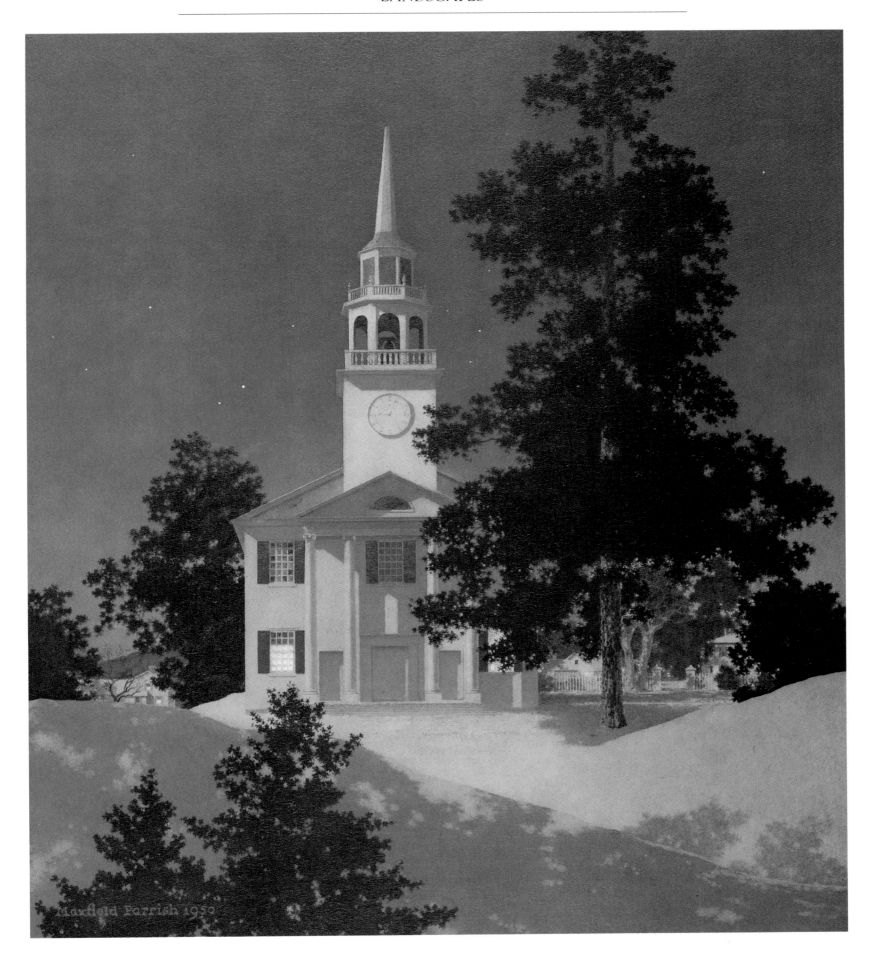

Left:
The Glen, 1936
Oil on masonite, 33¼ × 28 in.
Brown and Bigelow Calendar, 1938
Courtesy: The American Illustrators Gallery (LUD 765)

Peaceful Night (Church at Norwich, Vermont), 1950
Oil on panel, 21½ × 17½ in.
Brown and Bigelow Calendar, 1953
Courtesy: The American Illustrators Gallery (LUD 824)

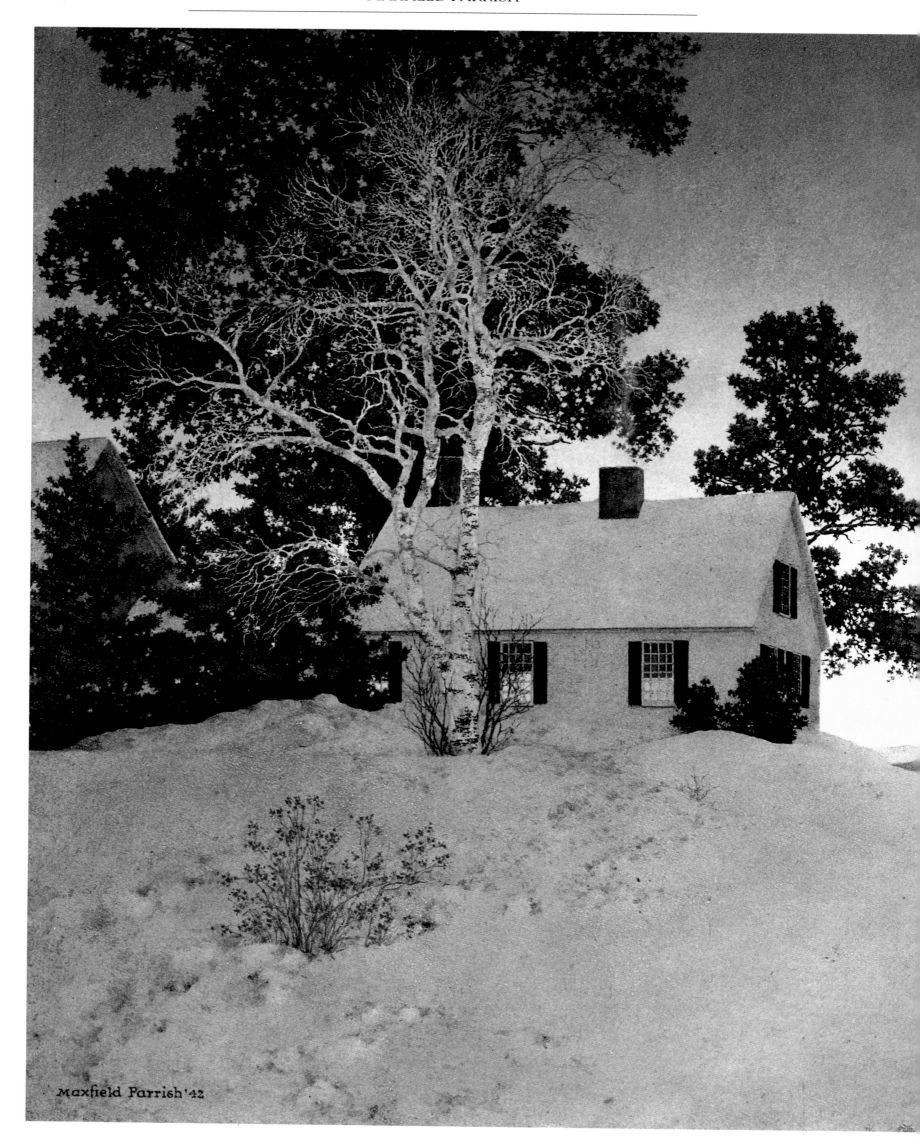

Dusk, 1942
Oil on canvas, 13¼ × 15¼ in.
Charles F. Smith Fund
New Britain Museum of American Art
New Britain, CT

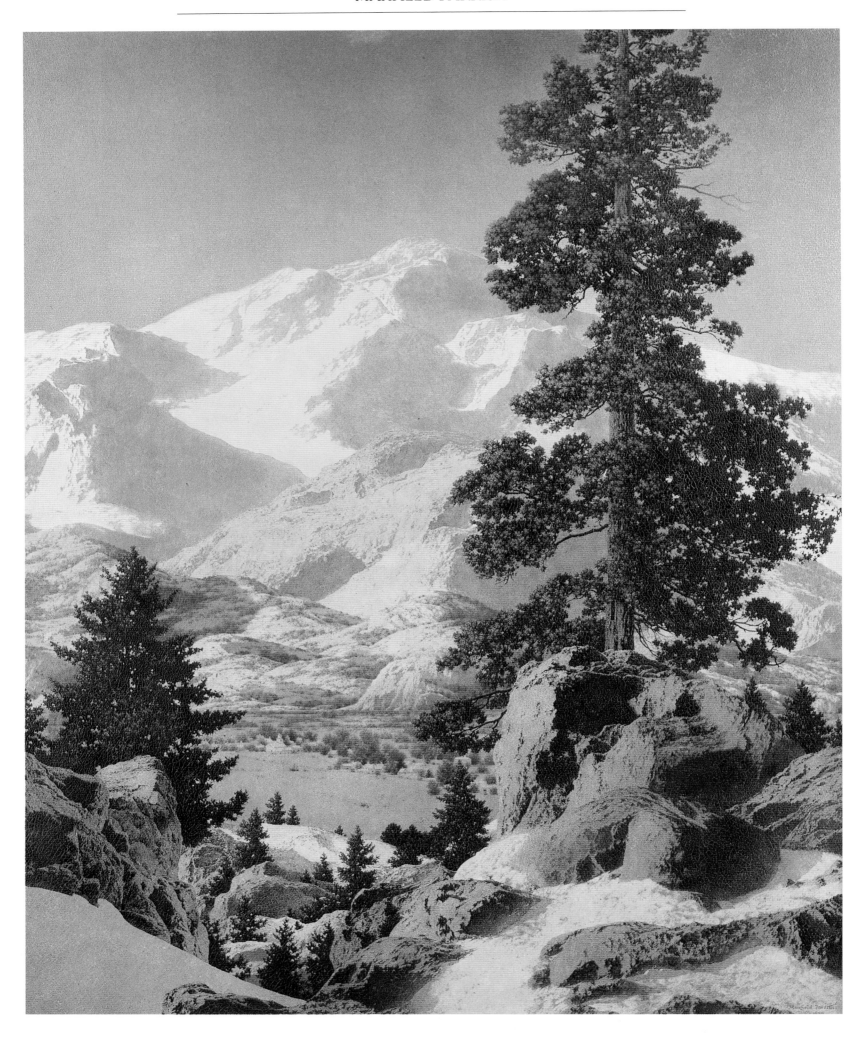

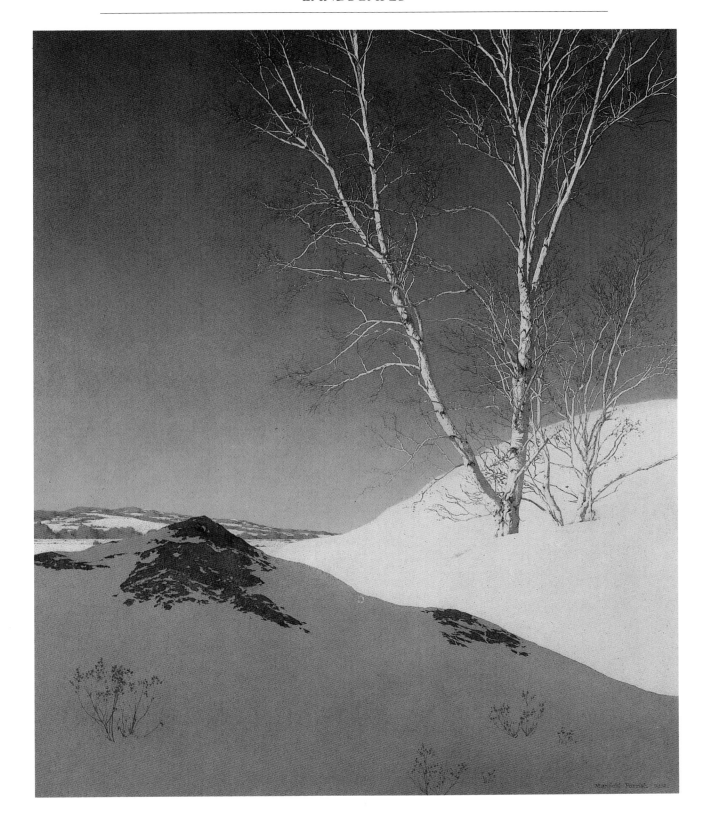

Left:
New Hampshire: The Winter Paradise, 1939
Oil on panel, 30½ × 24 in.
Winter poster for the New Hampshire Planning and
Development Commission
Private Collection
Courtesy: The American Illustrators Gallery (LUD 769)

White Birch Winter, 1931
Oil on panel, 25 × 20 in.
Courtesy: The American Illustrators Gallery

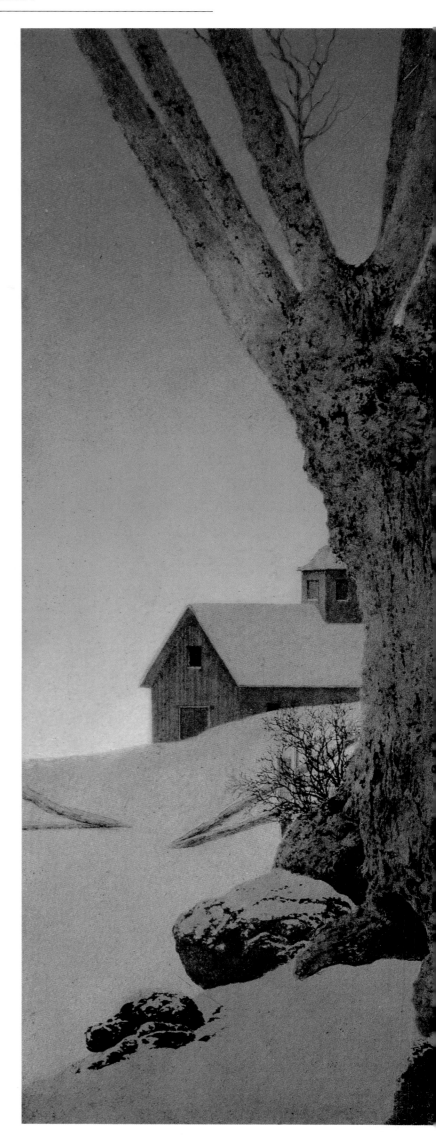

Christmas Morning, 1949
Oil on panel, 13 × 15 in.
Brown and Bigelow Calendar, 1949
Courtesy: The Museum of Fine Arts, Boston, MA (LUD 784)

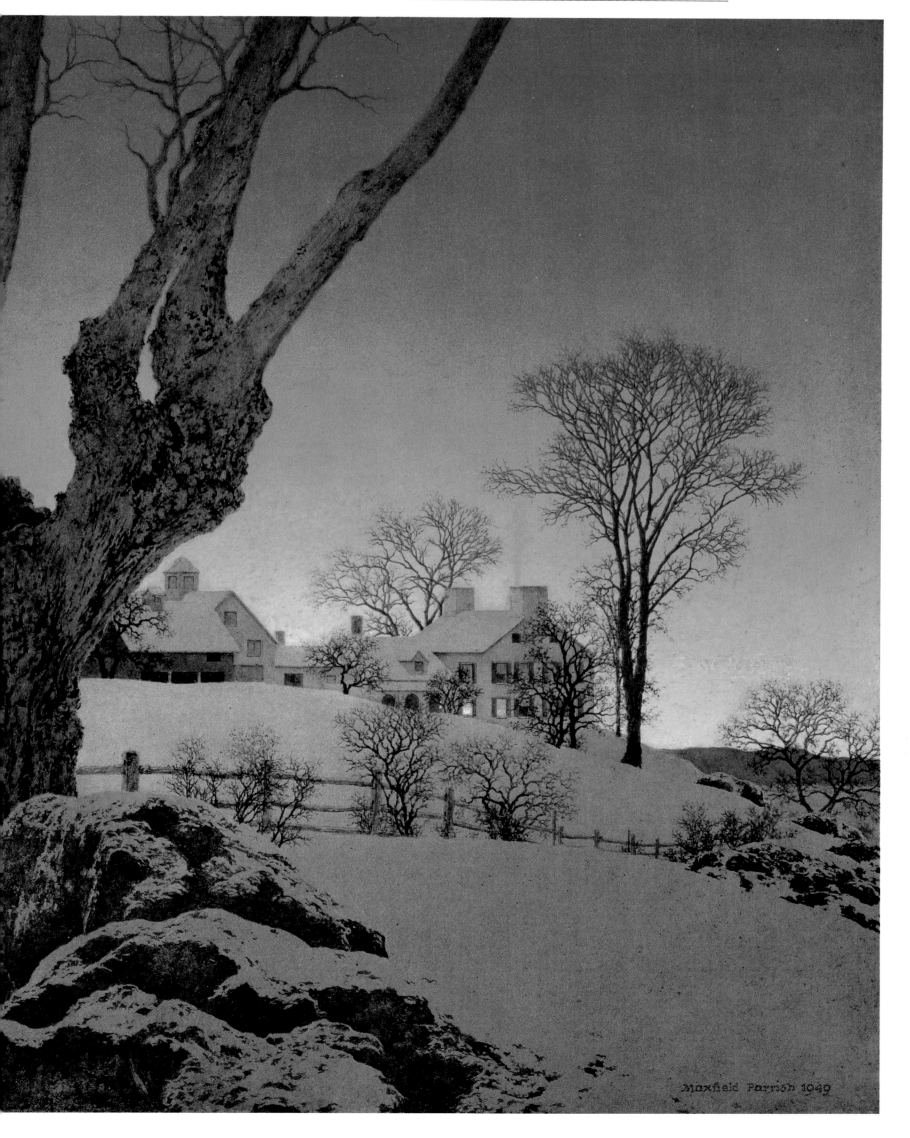

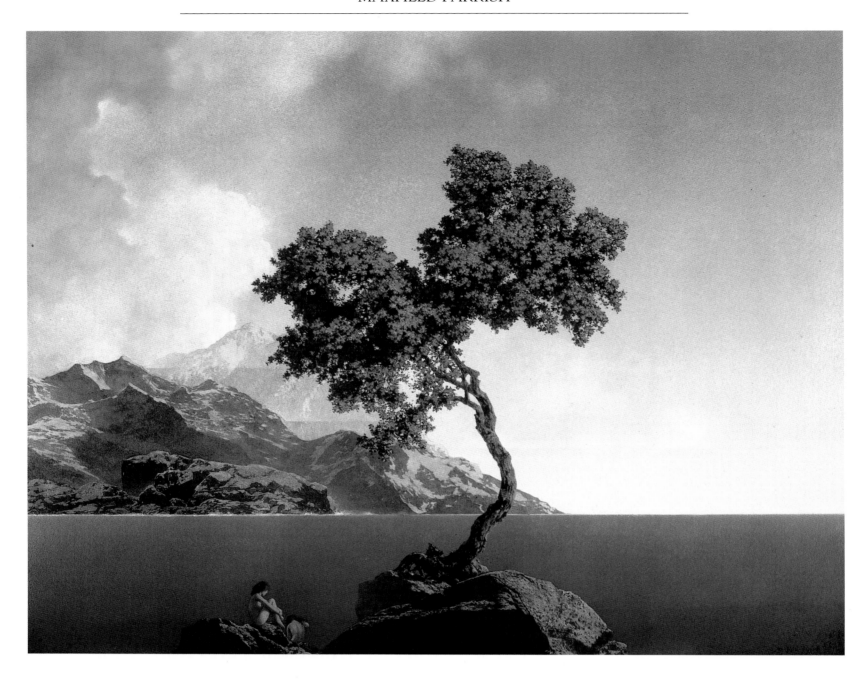

Right:
The Millpond, 1945
Oil on panel, 22½ × 18 in.
Brown and Bigelow Calendar, 1948
Private Collection
Courtesy: The American Illustrators Gallery (LUD 795)

Aquamarine, 1917
Oil on panel, 15½ × 19¼ in.
Courtesy: The American Illustrators Gallery

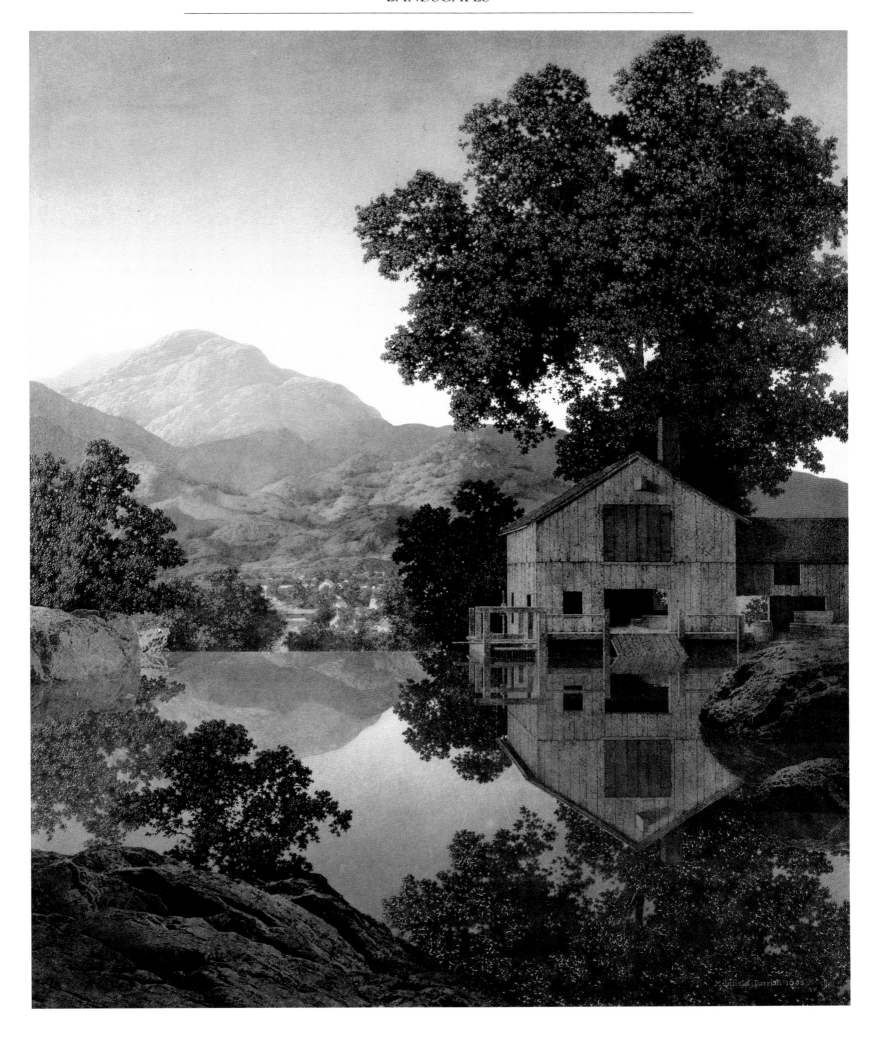

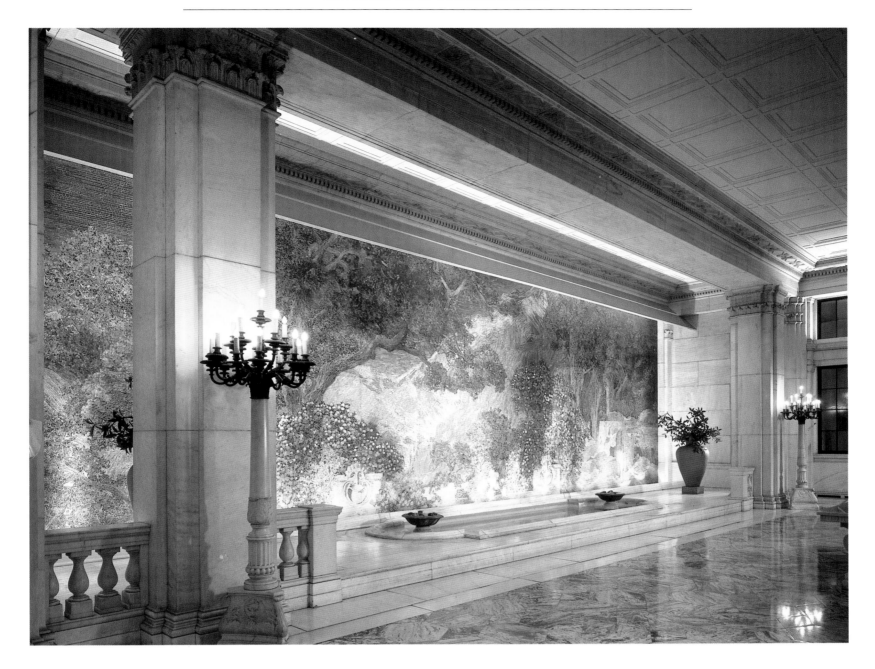

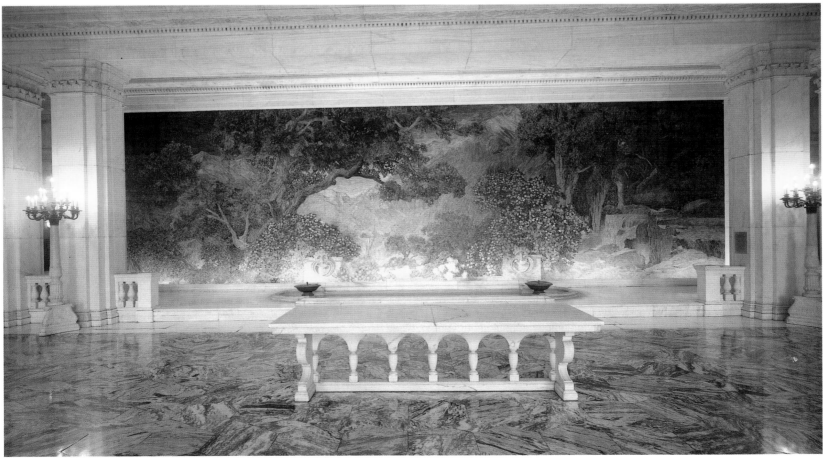

The Chaperone, 1892
Oil on panel, 28½ × 21 in.
Door of Sail Loft, Annisquam, MA
Private Collection
Courtesy: The American Illustrators Gallery

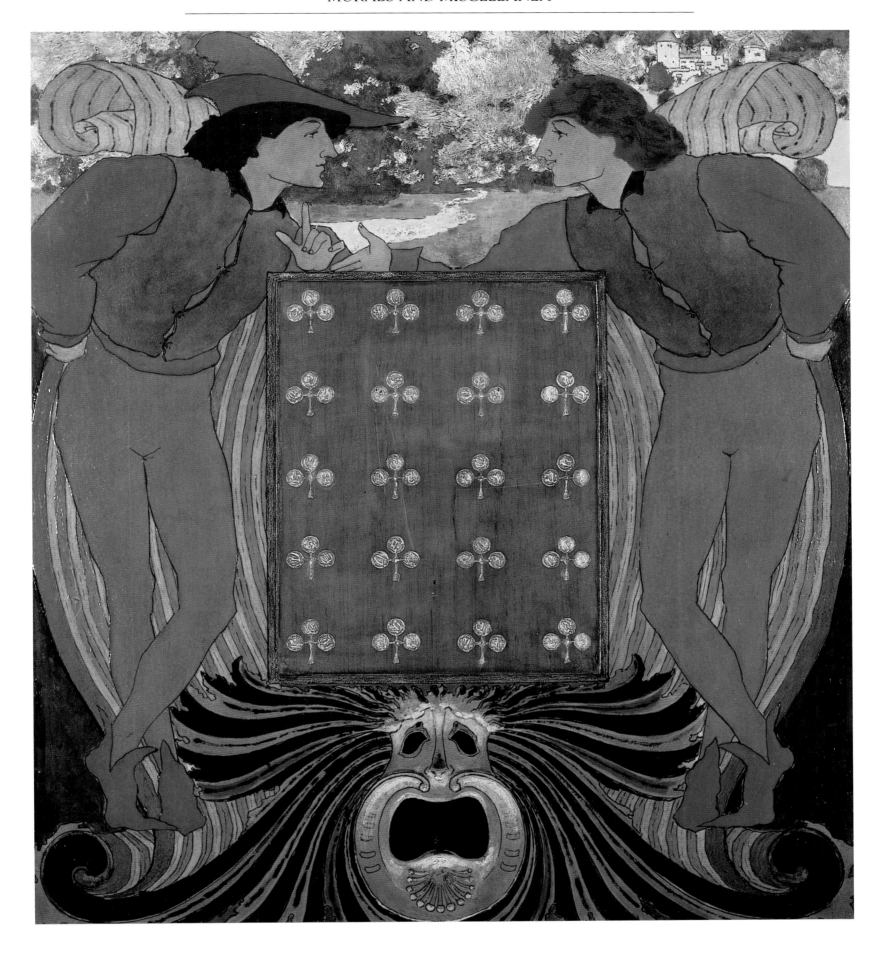

Presentation Design for the bulletin board
at the Mask and Wig Clubhouse, Philadelphia, PA, 1896
Oil on paper, 22½ × 20½ in.
Private Collection
Courtesy: The American Illustrators Gallery

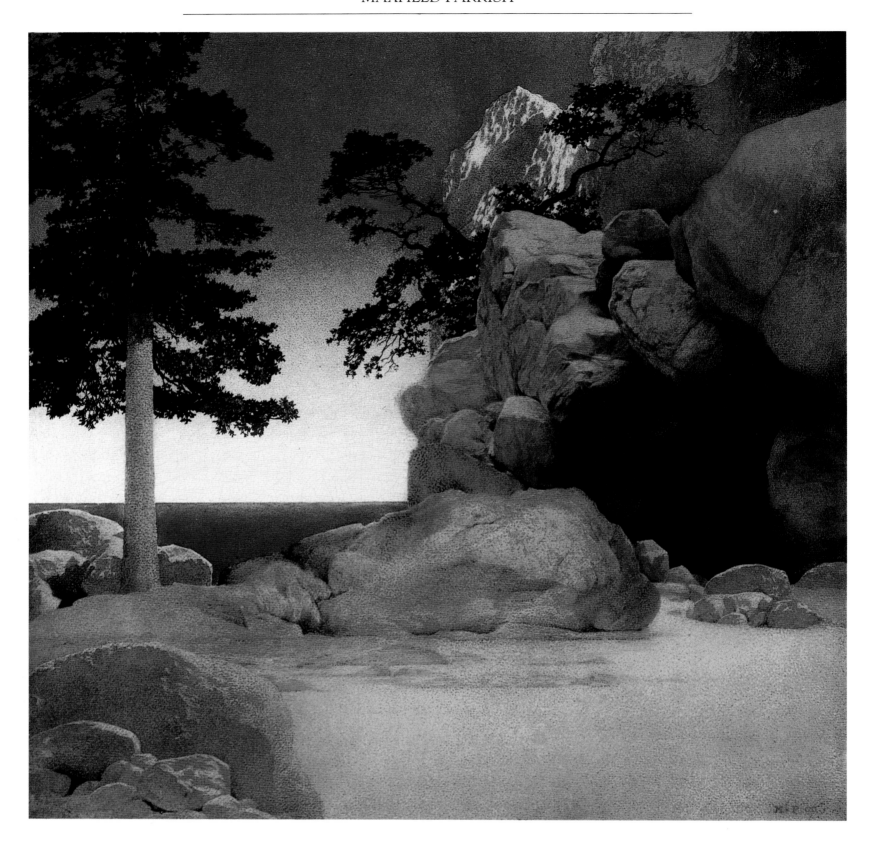

**A Strong-Based Promontory (The Yellow Sands Outside the
Cave)**, 1909
Oil on canvas, 16 × 16 in.
Designed for *The Tempest* by William Shakespeare,
at The New Theater, New York, NY
Courtesy: The American Illustrators Gallery (LUD 502)

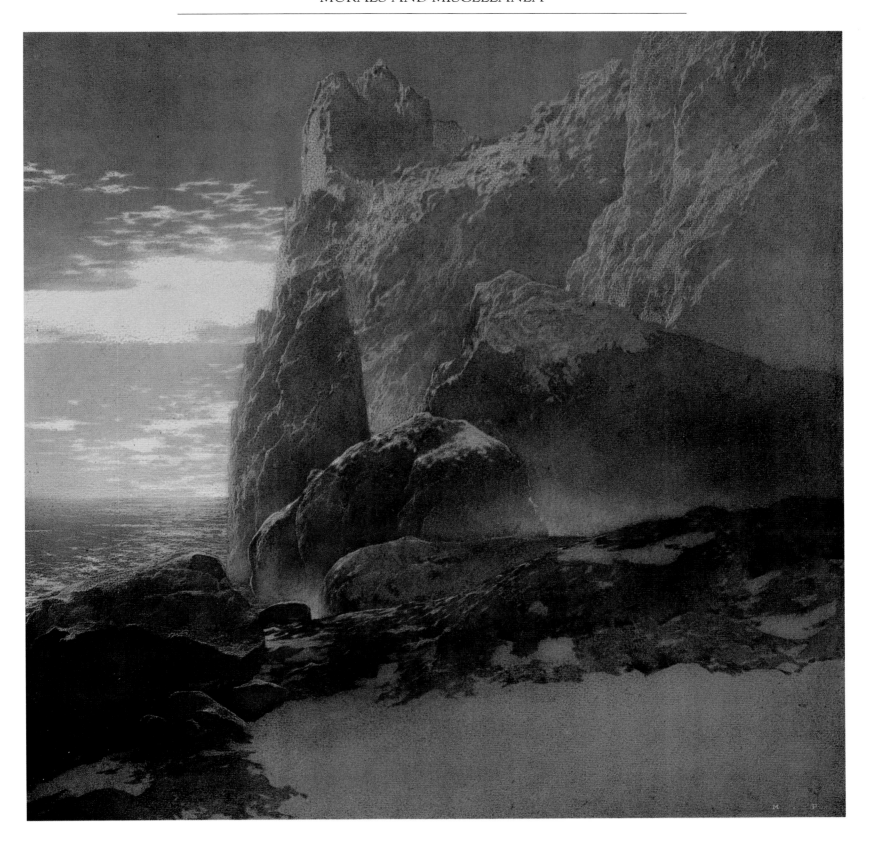

The Tempest, 1909
Oil on panel, 16 × 16 in.
Designed for *The Tempest* by William Shakespeare
at The New Theater, New York, NY
Courtesy: The American Illustrators Gallery (LUD 503)

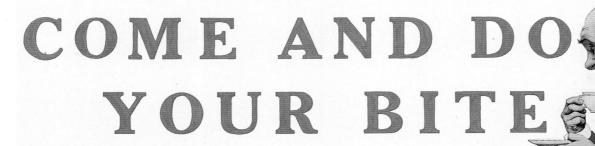

BRITISH WAR RELIEF
TEA AND FOOD SALE

SATURDAY MAY 24 1941

COME AND DO
YOUR BITE

NEW ENGLAND FOOD AND RECEIPTS
FOR SALE. PEOPLE IN COSTUMES OF
THE ALLIES WILL SELL FOOD AND
RECEIPTS FROM THEIR NATIVE
LANDS. **FROM 2:30 TILL 6 P.M.**
WINDSOR COUNTY COMMITTEE B.W.R.S.

Come and Do Your Bite, 1941
Oil on paper, collage on board, 24 × 30 in.
For the British War Relief Society Tea &
Food Sale Poster
Courtesy: The American Illustrators Gallery

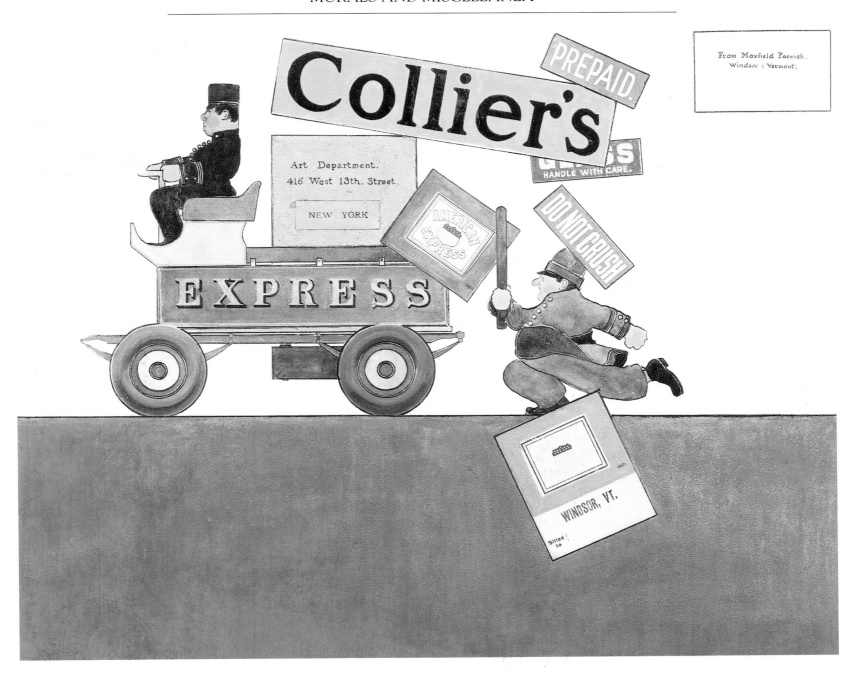

Collier's Funnygraph, 1905
Oil and collage on paper, 19 × 24 in.
Courtesy: The American Illustrators Gallery

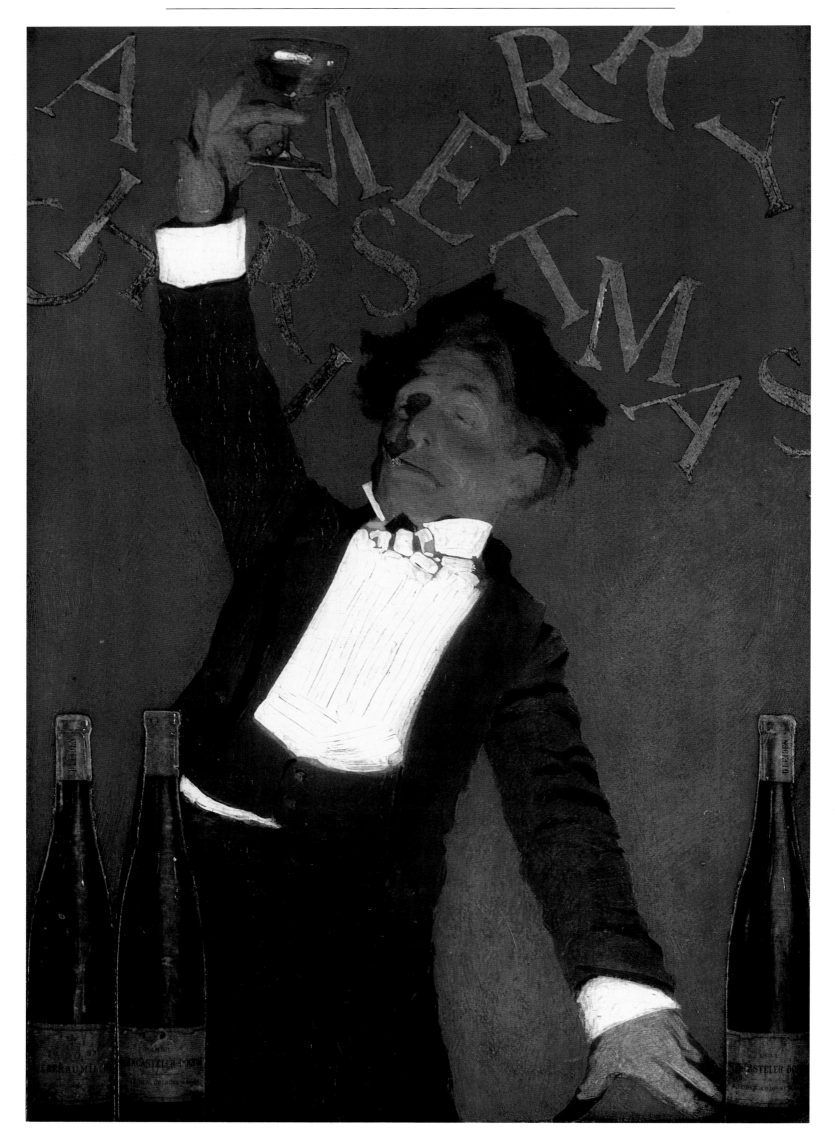

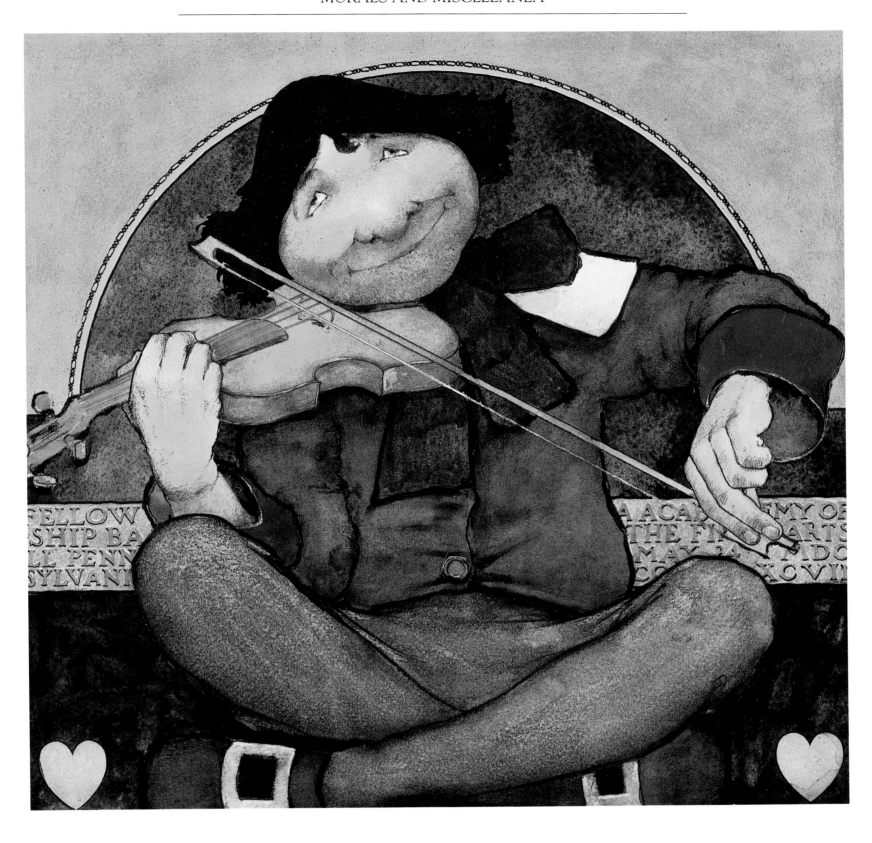

LIST OF COLOR PLATES